NEW YORK
architecture & design

Edited and written by Sean Weiss
Concept by Martin Nicholas Kunz

content

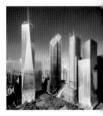

to see . culture & education

to see . public

content

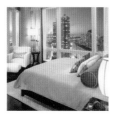 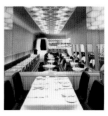

to stay . hotels

to go . eating, drinking, clubbing

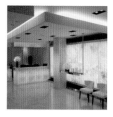

to go . wellness, beauty & sport

to shop . mall, retail, showrooms

index

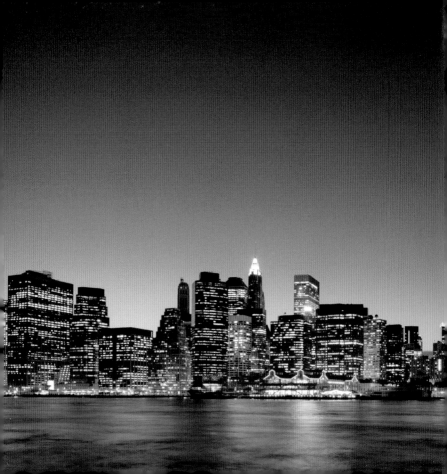

introduction

Hotel Gansevoort

New York Hall of Science

The competition to rebuild Ground Zero in 2002 propelled the social function of architecture into the forefront of public consciousness. This cause célèbre has lead architects and designers to enhance the possibilities of social interaction within New York's newest spaces. This guide leads its readers through New York's most riveting architectural projects including Taniguchi's MoMA expansion, Gluckman Mayner's latest residential building, and such interiors as Marc Newson's Lever House restaurant and Vitra's flagship store by Lindy Roy, all touting the highest degree of design integrity.

Der Wettbewerb zur Neugestaltung des Ground Zero im Jahr 2002 rückte die wichtige gesellschaftliche Funktion von Architektur ins öffentliche Bewusstsein und führte Architekten und Designer dazu, soziale Interaktion bei den neuesten New Yorker Bauten auszuloten. Dieser Führer präsentiert den Lesern die spannendsten Architekturprojekte New Yorks – einschließlich Taniguchis MoMa-Erweiterung, Gluckman Mayners erstem Wohngebäude sowie Innenräume wie Marc Newsons Restaurant Lever House und dem Vitra-Flagshipstore von Lindy Roy, die höchste Designstandards setzen.

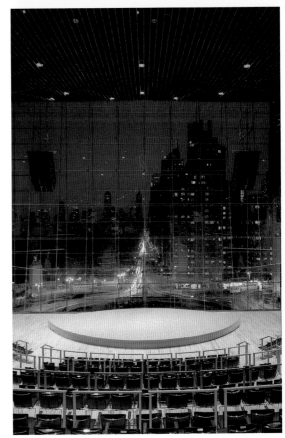

Jazz at Lincoln Center

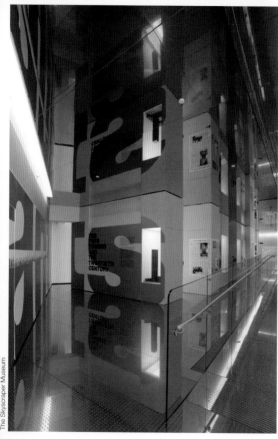

Le concours relatif à la reconstruction de Ground Zero organisé en 2002 a mis en avant l'importance de la fonction sociale de l'architecture et a conduit les architectes et les designers à rechercher une interaction sociale entre les bâtiments de New York les plus récents. Ce guide présente aux lecteurs les projets architecturaux les plus passionnants de New York, y compris l'agrandissement du MoMa par Taniguchi, le premier bâtiment résidentiel de Gluckman Mayner ainsi que ses pièces intérieures comme le Restaurant Lever House de Marc Newson et le magasin phare Vitra de Lindy Roy qui définissent des normes extrêmement élevées en matière de design.

El concurso para la remodelación del Ground Zero en el año 2002 acercó a la conciencia pública la importante función social de la arquitectura y empujó a los arquitectos y a los diseñadores a sondear la interacción social con los nuevos edificios de Nueva York. Esta guía presenta a los lectores los proyectos arquitectónicos más apasionantes de Nueva York, incluida la ampliación del MoMa de Taniguchi, el primer edificio de viviendas de Gluckman Mayner además de espacios interiores que asientan los estándares mas elevados del diseño, como el Restaurant Lever House de Marc Newson y la tienda bandera de Vitra de Lindy Roy.

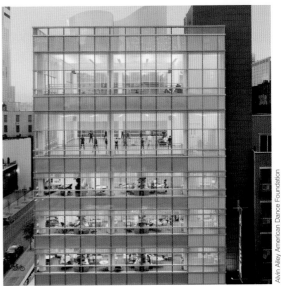

Alvin Alley American Dance Foundation

to see . living
office
culture & education
public

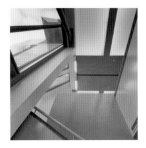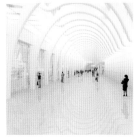

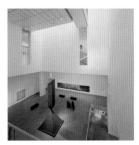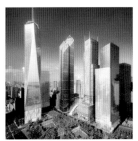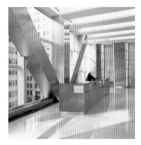

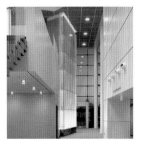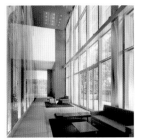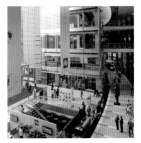

Downtown by Philippe Starck

Philippe Starck

2006
15 Broad Street
Lower Manhattan

www.downtownbystarck.com
www.philippe-starck.com

The *nonpareil* of decadent design, Philippe Starck, has transformed a former bank headquarters into apartments replete with sumptuous marbles, crystal chandeliers, and a myriad of his signature Louis XV furnishings.

Die mit Marmorböden, Kristallleuchtern und Louis-XV-Möbeln ausgestatteten Appartements in einer ehemaligen Bank tragen unverkennbar die ironisch-dekadente Handschrift des Designers Philippe Starck.

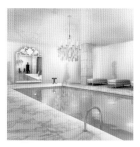

Aménagés dans une ancienne banque, les appartements dotés de sols en marbre, lustres en cristal et meubles Louis XV portent évidemment la signature ironiquement décadente du designer Philippe Starck.

Los apartamentos, equipados con suelos de mármol, lámparas de cristal y mobiliario en estilo Luis XV, están situados en el edificio de un antiguo banco y llevan la inconfundible firma irónica y decadente del diseñador Philippe Starck.

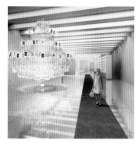

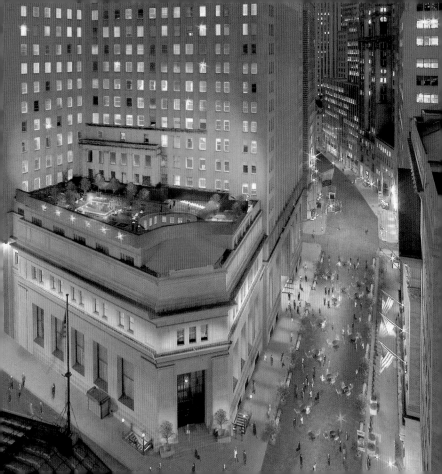

BLUE

Bernard Tschumi Architects

2006
105 Norfolk Street
Lower East Side

www.bluecondonyc.com
www.tschumi.com

Blue glass soars over the Lower East Side in this new residential development. The tower cantilevers over a commercial building and ascends in a slope featuring 32 apartment units.

Das blaue Glas dieses neuen Wohngebäudes erhebt sich über die Lower East Side. Der gekrümmte Turm, in dem sich 32 Appartements befinden, neigt sich über ein Geschäftsgebäude.

Le vitrage bleu de cette nouvelle résidence s'élève sur le Lower East Side. La tour incurvée abrite 32 appartements et s'incline sur un bâtiment réservé aux affaires.

El vidrio azul de este nuevo edificio de viviendas se levanta por encima de la Lower East Side. La torre torcida, que alberga 32 apartamentos, se inclina sobre un edificio comercial.

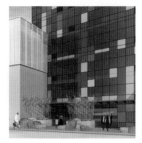

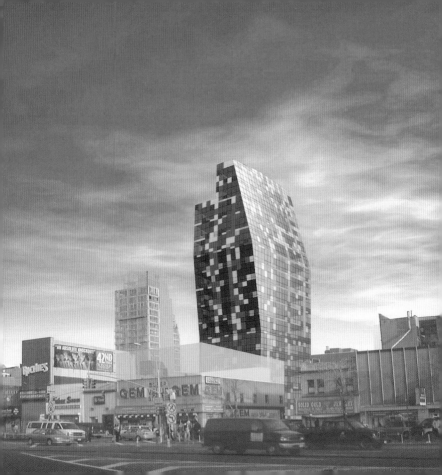

Norfolk Street Residences

Grzywinski Pons Architects

2007
115-119 Norfolk Street
Lower East Side

www.gp-arch.com

Transparency triumphs at this Lower East Side residential complex. The façade's curtain wall reveals an interior assemblage of materials and massing, culminating in a roof-deck with pool.

Transparenz kennzeichnet diesen Wohnkomplex an der Lower East Side. Die Vorhangfassade gibt den Blick auf verschiedenste Materialien und Raumvolumen frei. Ein Swimmingpool auf dem Dach bildet den Höhepunkt.

C'est la transparence qui caractérise ce complexe résidentiel situé sur le Lower East Side. La façade rideau met en évidence la variété des matériaux et le volume spatial. La piscine sur le toit constitue la cerise sur le gâteau.

La transparencia caracteriza este complejo de viviendas en la Lower East Side. La fachada de muro cortina permite ver los más diversos materiales y el volumen del espacio. Lo más sobresaliente es la piscina en el tejado.

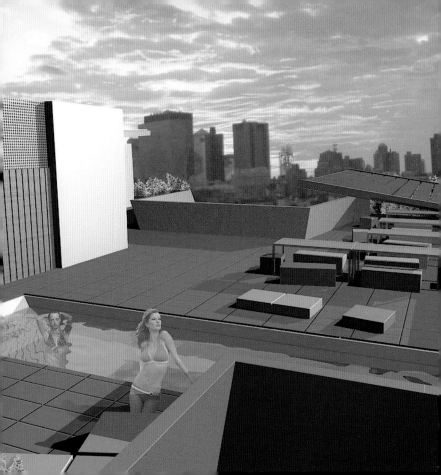

The Porter House

SHoP

2003
66 9th Avenue
Meatpacking District

www.shoparc.com

A six-story addition clad in zinc rises from a landmarked Renaissance revival warehouse from 1905. Internally mounted light boxes accent vertical windows while also illuminating the surrounding street at night.

Der in Zink gehaltene sechsstöckige Aufbau erhebt sich über einem unter Denkmalschutz stehenden Lagerhaus aus dem Jahr 1905. Innen angebrachte Lichtboxen betonen die vertikalen Fensterbänder und strahlen nachts auf die darunter liegende Straße aus.

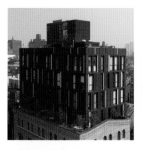

L'édifice en zinc de six étages s'élève au-dessus d'un entrepôt datant de 1905 classé monument historique. Les boîtes lumineuses apposées à l'intérieur mettent en valeur les rangées de fenêtres verticales ; la nuit, elles éclairent la rue située en dessous.

El edificio de seis plantas conservado en cinc se yergue sobre un almacén del año 1905 protegido como monumento histórico. Las cajas de luz instaladas en el interior subrayan los ventanales verticales y, por la noche, iluminan la calle de abajo.

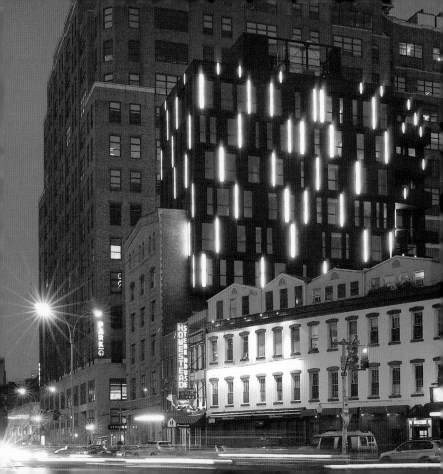

Greenwich Street Project

Archi-Tectonics

2004
497 Greenwich Street
Soho

www.archi-tectonics.com

The conversion of a six-story warehouse building and addition of a four-story penthouse on top integrates the strict building set-back codes into a new pleated, 10,000 square foot glass façade. The juxtaposition of the small crease rising between the two structures and cantilevered balconies differentiates the old and the new.

La rénovation d'un entrepôt de six étages et sa surélévation avec une mansarde sur quatre étages fait apparaître, compte tenu de la réglementation stricte du bâtiment selon laquelle les étages supérieurs doivent ressortir, une nouvelle façade pliée en verre de près de 1000 m². Le renfoncement étroit entre les deux édifices et les balcons en saillie séparent l'ancien bâtiment du nouveau.

Durch den Umbau eines sechsgeschossigen Lagerhauses und dessen Aufstockung mit einem viergeschossigen Penthouse entsteht unter Einhaltung der strengen Bauvorschriften, nach denen die oberen Geschosse zurückspringen müssen, eine neue, gefaltete, fast 1000 m² große Glasfassade. Ein schmaler Rücksprung zwischen den zwei Baukörpern und die auskragenden Balkone trennen Altes von Neuem.

Con la remodelación de un almacén de seis plantas y su ampliación con un penthouse de cuatro pisos, respetando las estrictas reglamentaciones de la construcción según las cuales los pisos superiores deben retraerse, surge una nueva fachada de cristal en forma de pliegues con una superficie de casi 1000 m². Un estrecho retranqueado entre los dos cuerpos del edificio y los balcones saledizos separa lo viejo de lo nuevo.

40 Mercer Residences

Atelier Jean Nouvel

2007
40 Mercer Street
Soho

www.40mercersoho.com
www.jeannouvel.com
www.andrebalazsproperties.com

High modernism's grid has been revitalized to propel purity into the city of the 21st century. Interiors boasting floor to ceiling windows translate on the exterior with a 15-story curtain wall with alternating polychromed and clear panes of glass.

Die Rasterfassade der Moderne wurde wiederbelebt, um einen puristischen Akzent in der Stadt des 21. Jahrhunderts zu setzen. Die großspurigen Innenräume sind durch die vom Boden bis zur Decke reichenden Fenster der 15-stöckigen Vorhangfassade sichtbar, bei der sich farbige und klare Glasscheiben abwechseln.

La façade à trame de l'époque moderne a été rajeunie pour ajouter un accent puriste dans la ville du 21ème siècle. Les pièces intérieures très généreuses sont visibles par les fenêtres, allant du sol au plafond, de la façade rideau de 15 étages sur laquelle s'alternent vitres colorées et vitres transparentes.

Para establecer un acento purista en la ciudad del siglo XIX se retomó la fachada cuadriculada de la arquitectura moderna. Los grandiosos espacios interiores son visibles a través de la fachada de muro cortina de este edificio de 15 plantas y en ella los ventanales transparentes alternan con los de color.

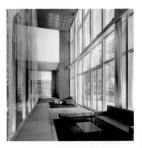

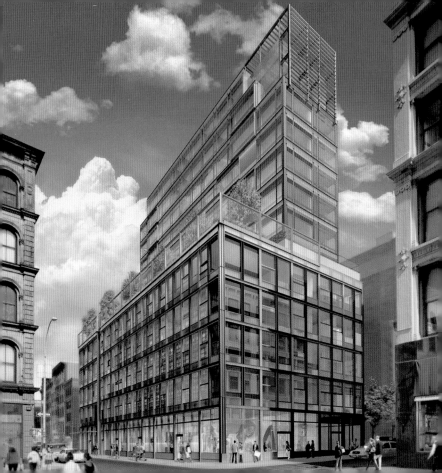

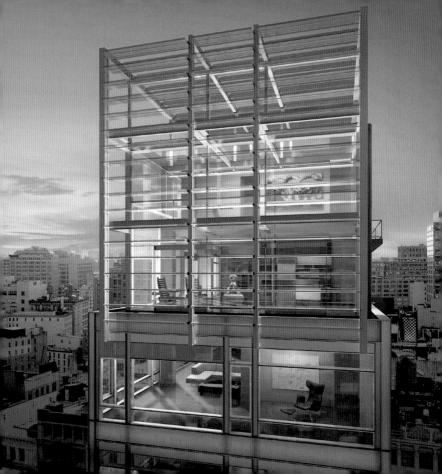

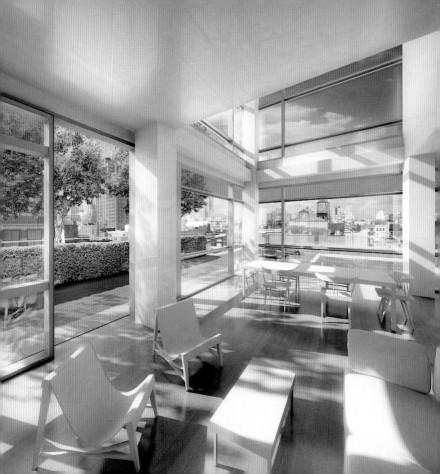

One Kenmare Square

Gluckman Mayner Architects

2006
210 Lafayette Street
Soho

www.kenmaresquare.com
www.gluckmanmayner.com
www.andrebalazsproperties.com

Vertical glass and brick strips undulate along the façade. Each material serves a unique purpose. Large ribbon windows provide light and unobstructed views, and brick cladding maintains uniformity throughout the neighborhood's built environment.

Vertikale Glas- und Ziegelstreifen bilden eine gewellte Fassade. Jedes Material erfüllt dabei seinen eigenen Zweck. Große Fensterbänder bieten Licht und unverbaute Blicke, während die Ziegelsteinverkleidung eine Verbindung zu den Gebäuden der Umgebung herstellt.

Les rangées verticales en verre et en tuile font apparaître une façade ondulée. Chaque matériau a sa propre raison d'être. Les grandes rangées de fenêtres rendent le bâtiment lumineux et offrent un panorama très large, tandis que le revêtement en tuiles crée un lien avec les bâtiments voisins.

Las franjas de cristal y de ladrillo crean una fachada ondulada. Cada material desempeña una función. Los grandes ventanales proporcionan luz y una vista libre, mientras que la piel de ladrillo establece la relación con los edificios del entorno.

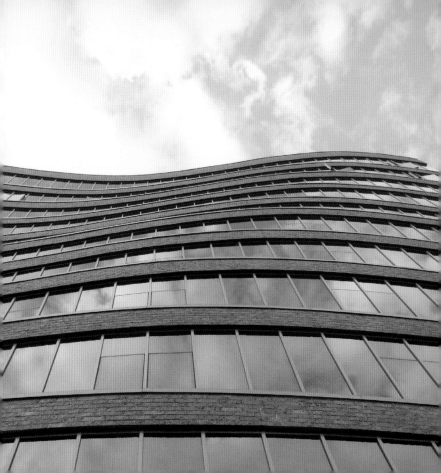

1 York Tribeca

TEN Arquitectos
Enrique Norten

2006
1 York Street
Tribeca

www.1york.com
www.ten-arquitectos.com

A new glass core marks the conversion of this pre-Civil War manufacturing building. The core expands vertically above the older structure to provide six stories of apartments with cascading natural light and views of the city.

Ein neues gläsernes Zentrum bestimmt die Umnutzung dieses Industriegebäudes, das aus der Zeit vor dem Bürgerkrieg stammt. Der sich nach oben ausdehnende Glaskern schwebt über dem alten Bauwerk. So entstehen sechs Stockwerke mit lichtdurchfluteten Appartements, die Ausblicke über die Stadt bieten.

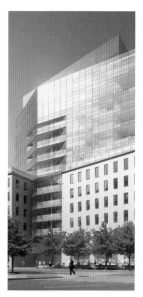

Le nouveau centre en verre détermine la nouvelle utilisation de ce bâtiment industriel qui date de l'époque précédant la guerre de Sécession. Le noyau vitré s'élevant vers le haut est suspendu au-dessus de l'ancien édifice. Ces six étages aux appartements baignés de lumière offrent un superbe panorama sur la ville.

Un nuevo centro de cristal determina el cambio de uso de este edificio industrial que data de la época de la Guerra de Secesión. El núcleo de cristal se dilata hacia arriba sobre el viejo edificio. Surgen así seis plantas con apartamentos luminosos con vistas sobre la ciudad.

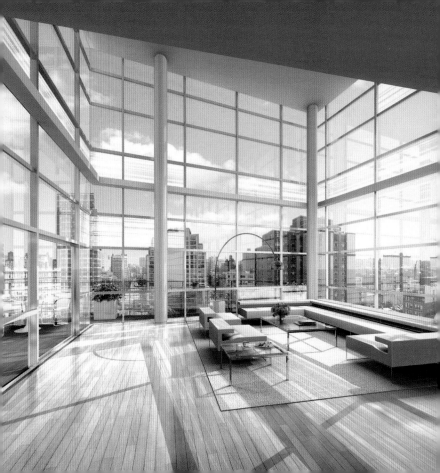

Memory Foundations
World Trade Center Master Plan

Daniel Libeskind

2012
West Street/Church Street
Lower Manhattan

www.renewnyc.com
www.wtc.com
www.daniel-libeskind.com

Libeskind's winning master plan proposal Memory Foundations mediates memory and urban growth. Five skyscrapers will surround Michael Arad's and Peter Walker's memorial and flank SOM's Freedom Tower.

Libeskinds siegreicher Masterplan der Memory Foundation vermittelt zwischen Erinnerung und städtischem Wachstum. Fünf Wolkenkratzer werden das Denkmal von Michael Arad und Peter Walker umstehen und SOMs Freedom Tower flankieren.

Le schéma directeur vainqueur de Libeskind pour la Memory Foundation établit un lien entre la mémoire et la croissance urbaine. Cinq gratte-ciels entoureront le mémorial Michael Arad et Peter Walker et flanqueront la Freedom Tower de l'agence SOM.

El proyecto magistral ganador de Libeskind para la Memory Foundation concilia la memoria con el crecimiento urbano. Cinco rascacielos rodearán el monumento de Michael Arad y Peter Walker y flanquearán la Freedom Tower de SOM.

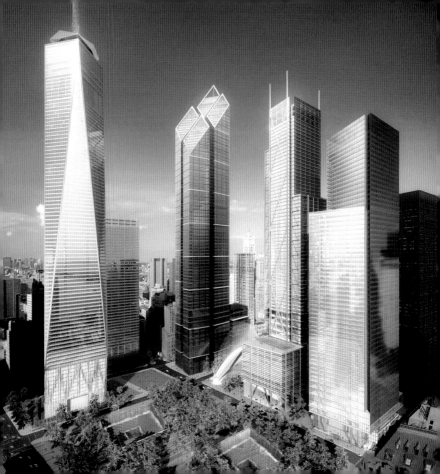

10. **Tower 4, WTC**
Maki and Associates

2012
150 Greenwich Street
Lower Manhattan

www.renewnyc.com
www.maki-and-associates.co.jp

11. **Tower 3, WTC**
Richard Rogers Partnership

2012
175 Greenwich Street
Lower Manhattan

www.renewnyc.com
www.richardrogers.co.uk

12. **Tower 2, WTC**
Foster and Partners

2012
200 Greenwich Street
Lower Manhattan

www.renewnyc.com
www.fosterandpartners.com

Freedom Tower

Skidmore, Owings & Merrill LLP

2010
West Street/Church Street
Lower Manhattan

www.renewnyc.com
www.som.com

The key architectural structure in the effort to rebuilt the site of the former World Trade Center will recapture New York's skyline as the tower soars 1776 feet into the sky in celebration of the independence of the United States.

Dieses Schlüsselbauwerk auf dem Gelände des World Trade Center wird künftig die Skyline New Yorks dominieren. Die Höhe von 1776 Feet (541 Metern) spielt auf das Unabhängigkeitsjahr der Vereinigten Staaten an.

Cet ouvrage-clé construit sur l'emplacement du World Trade Center dominera à l'avenir la skyline de New York. Sa hauteur de 1776 pieds (541 mètres) fait référence à l'année de l'indépendance des États-Unis.

Esta obra clave en el solar del World Trade Center será el futuro elemento dominante en el horizonte de Nueva York. La altura de 1.776 pies (541 metros) evoca el año de la independencia de los Estados Unidos.

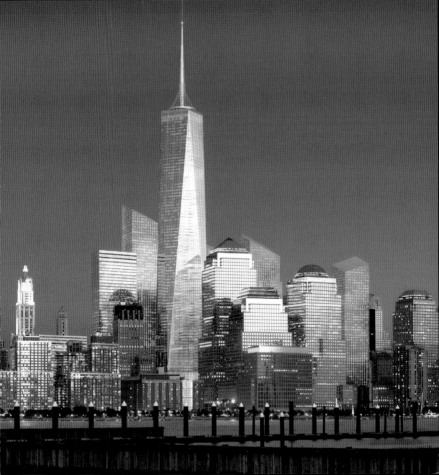

The New York Times Building

Renzo Piano Building Workshop
FXFOWLE Architects PC

2007
620 8th Avenue
Times Square

www.nytimes.com
www.rpbw.com
www.fxfowle.com

The glass curtain walls and scrim of white ceramic tubes facades in the new 52-story New York Times headquarters acts as an energy efficient sunscreen, captures and reflects the shimmering and colors of the city's light. The transparent and permeable concept is reflected at street level with the public spaces and interior garden.

Die Glasvorhangfassade der neuen, 52-geschossigen Konzernzentrale der New York Times mit ihrer Vielzahl von weißen Keramikröhren wirkt wie ein energieeffizienter Sonnenschild, der den Glanz und die Farben des New Yorker Lichts einfängt und reflektiert. Das transparente und durchlässige Konzept setzt sich im Erdgeschoss in Form von öffentlichen Räumen und einem Innengarten fort.

La façade rideau en verre du nouveau siège central de 52 étages du groupe New York Times avec son nombre important de tuyaux blancs en céramique donne l'impression d'un panneau solaire à rentabilité énergétique qui capte et reflète l'éclat et les couleurs de la lumière newyorkaise. Le concept transparent et perméable se poursuit au rez-de-chaussée sous la forme de pièce publiques et d'un jardin intérieur.

La fachada cortina de cristal de la nueva central del consorcio New York Times, de 52 pisos, produce con sus numerosos tubos de cerámica blanca la impresión de una eficiente placa solar que capta y refleja el brillo y los colores de la luz neoyorquina. El concepto transparente y traslúcido se prolonga en la planta baja en forma de espacios públicos y un jardín interior.

Times Square Tower

Skidmore, Owings & Merrill LLP

2004
7 Times Square
Times Square

www.timessquaretower.com
www.som.com

This tall building flanks the south-ern-most contours of Times Square's dynamic commercial district. Building upon the iconic visual language of the area, the tower itself hosts a surfeit of bill-boards and advertisements.

Dieses schlanke Gebäude mar-kiert das südliche Ende des dy-namischen Geschäftsviertels des Times Square. Entsprechend dem charakteristischen Erschei-nungsbild der Umgebung, ist es ebenfalls von Leuchtreklameta-feln übersät.

Cette tour élancée délimite le sud du quartier des affaires très dynamique de Times Square. Conformément à l'aspect ca-ractéristique des gratte-ciel environnants, elle est également constellée de panneaux publici-taires lumineux.

Esta estilizada construcción re-marca el extremo sur del dinámi-co barrio de comercios de Times Square. Acorde con la imagen del entorno, el edificio también está cubierto de pantallas lumi-nosas.

Hearst Headquarters

Foster and Partners

2006
300 West 57th Street
Midtown

www.hearst.com
www.fosterandpartners.com

This 46-story tower features a diagonal grid that rises from a preexisting six-story base. As New York's first completely green building, sustainable features allow for the conservation of the city's natural resources.

Der Turm mit seinen 46 Etagen und der diagonalen Gitterstruktur erhebt sich aus einem älteren sechsstöckigen Sockelgebäude. Bei New Yorks erstem konsequent ökologischen Gebäude werden durch die Verwendung nachhaltiger Elemente die natürlichen Ressourcen der Stadt geschont.

La tour de 46 étages et sa structure grillagée en diagonale s'élève à partir d'un socle plus ancien de six étages. Premier édifice de New York accordant une priorité à l'écologie, le recours à des éléments durables permet d'économiser les ressources naturelles de la ville.

La torre, con sus 46 pisos y su estructura diagonal reticular, se levanta sobre una base más antigua de seis plantas. En este edificio, el primero de Nueva York que es ecológico de forma consecuente, los recursos naturales de la ciudad se protegen empleando elementos duraderos.

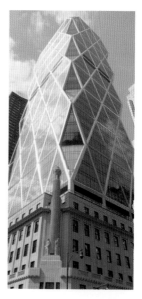

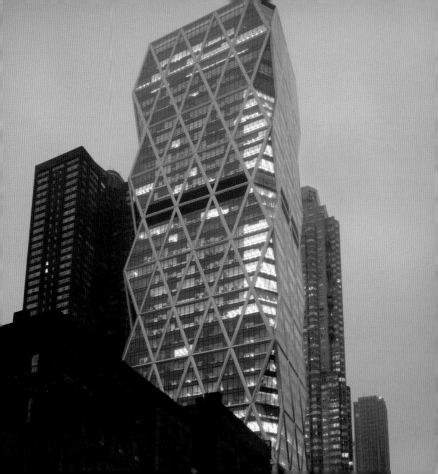

Harlem Park

TEN Arquitectos
Enrique Norten

2003
East 125th Street/Park Avenue
Harlem

www.ten-arquitectos.com

A beacon of the new Harlem Renaissance, the prominent profile of this tower enhances the uptown skyline. The multi-purpose superstructure incorporates commercial, residential, and office spaces, as well as a hotel.

Als Zeichen für die neue Harlem-Renaissance bestimmt das auffällige Profil dieses Turms die Skyline von Uptown New York. Das multifunktionale Gebäude umfasst Geschäfte, Wohnungen und Büros sowie ein Hotel.

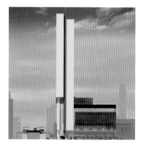

Symbole de la nouvelle Renaissance de Harlem, le profil imposant de cette tour détermine la skyline de Uptown New York. Le bâtiment multifonctionnel compte des magasins, des appartements, des bureaux et un hôtel.

El llamativo perfil de esta torre en el horizonte del norte de Nueva York es un símbolo del nuevo renacimiento de Harlem. El edificio multifuncional alberga tiendas, viviendas y oficinas además de un hotel.

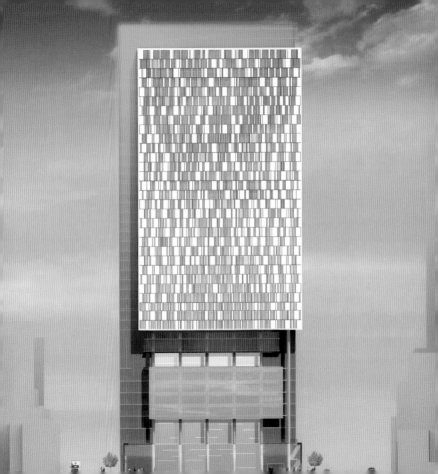

The Skyscraper Museum

Skidmore, Owings & Merrill LLP

2004
39 Battery Place
Lower Manhattan

www.skyscraper.org
www.som.com

For a museum wholly dedicated to tall buildings housed within a remarkably horizontal space, the firm most renown for skyscrapers, SOM, achieves an astonishing illusion of verticality with a mirror-polished stainless steel floor and ceiling.

Für ein Museum, das sich ausschließlich hohen Bauwerken widmet, sind die Räume bemerkenswert horizontal angelegt. Das für seine Wolkenkratzer berühmte Architekturbüro SOM erreicht mit einem Boden und einer Decke aus rostfreiem, blank poliertem Stahl eine verblüffende Illusion von Vertikalität.

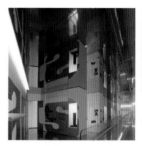

Pour un musée consacré exclusivement aux édifices élevés, les pièces sont disposées de manière remarquablement horizontale. Connu pour ses gratte-ciels, le bureau d'architectes SOM crée une illusion de verticalité surprenante avec un sol et un plafond réalisés en acier inoxydable et poli.

Para un museo dedicado exclusivamente a edificios de altura, las líneas de las salas resultan marcadamente horizontales. El estudio de arquitectos SOM, conocido por su rascacielos, logra una sorprendente ilusión de verticalidad gracias al suelo y al tejado de acero inoxidable y pulido.

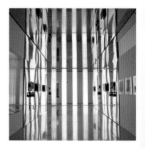

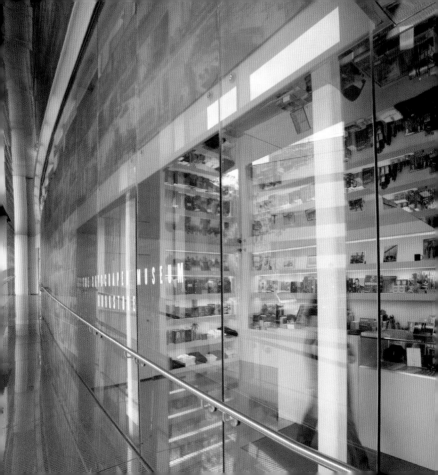

The Cooper Union
New Academic Building

Thom Mayne/Morphosis

2008
41 Cooper Square
Greenwich Village

www.cooper.edu
www.morphosis.net

Conceived as a vertical campus, classrooms and labs are arranged around a central atrium that soars to the top of the interior. A semi-transparent envelope flows along the façade, ostensibly bringing the neighborhood into the building.

Da das Projekt als vertikaler Campus geplant ist, werden die Unterrichtsräume und Labors rund um ein zentrales Atrium angeordnet, das sich nach oben weitet. Die fließende, halbtransparente Gebäudehülle soll die Umgebung hineinholen.

Étant donné que le projet met l'accent sur un campus vertical, les salles de cours et les laboratoires sont disposés autour d'un atrium central qui s'élargit vers le haut. L'enveloppe fluide et à moitié transparente du bâtiment a pour but d'intégrer les lieux environnants.

Como el proyecto está planificado como un campus vertical, las aulas y los laboratorios están dispuestos alrededor de un atrio central que se ensancha hacia arriba. La piel del edificio, fluida y semitransparente, introduce el entorno en el interior del edificio.

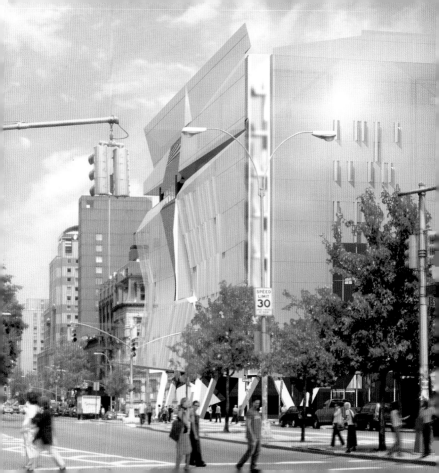

Plane Space Gallery

Deborah Berke & Partners Architects LLP

2002
102 Charles Street
West Village

www.plane-space.com
www.dberke.com

Among the myriad of New York's new galleries, seemingly minimal design dissolves this gallery space to accentuate art works. Yet, carefully deployed natural and artificial light provides ingenious solutions to accommodate the needs of changing exhibitions.

Unter den zahlreichen neuen Galerien in New York zeichnet sich diese durch ein minimalistisches Design aus, um die Kunstwerke ins Zentrum zu stellen. Behutsam eingesetztes natürliches und künstliches Licht bietet raffinierte Möglichkeiten für die unterschiedlichen Anforderungen wechselnder Ausstellungen.

Parmi les nombreuses galeries nouvelles de New York, celle-ci se distingue par son design minimaliste permettant de placer les œuvres d'art au centre de tout. Utilisées avec soin, la lumière naturelle et la lumière artificielle offrent des possibilités sensationnelles pour les différentes exigences des expositions provisoires.

De entre las numerosas galerías nuevas de Nueva York, ésta destaca por su diseño minimalista que sitúa las obras de arte en el centro. La luz natural y artificial, cuidadosamente empleadas, ofrece sutiles posibilidades para las diferentes necesidades de cada exposición.

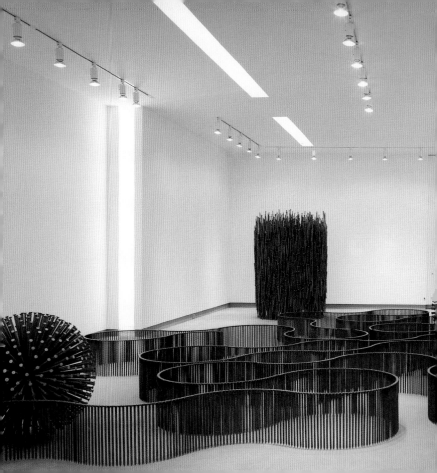

Austrian Cultural Forum

Raimund Abraham

2002
11 East 52nd Street
Midtown

www.acfny.org

A lean tower clad in glass tapers and recedes diagonally as it rises. The exterior is broken into geometries with panels held in suspension along with a cube projecting out of the façade containing the director's office.

Ein schlanker, mit Glas verkleideter Turm verjüngt sich und tritt nach oben hin diagonal zurück. Das Äußere wird durch vorgehängte Fassadenteile gebrochen. In einem Kubus, der aus der Fassade hervortritt, befindet sich das Büro des Direktors.

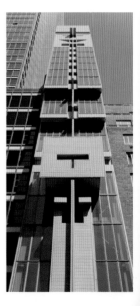

Une tour mince et recouverte de verre rajeunit son apparence et se rétrécit en diagonale vers le haut. L'aspect extérieur est rompu par des éléments de façade rideau. Le bureau du directeur a été aménagé dans un cube qui ressort de la façade.

Una delgada torre revestida con cristal se estrecha y retrae diagonalmente conforme gana en altura. El exterior es interrumpido por partes de fachada de muro cortina. En un cubo que sobresale de la fachada se encuentra el despacho del director.

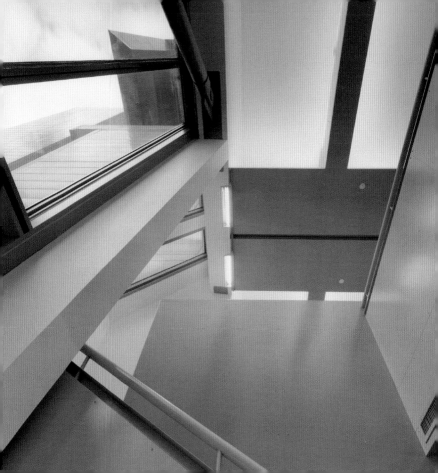

Museum of Modern Art

Taniguchi Associates
Kohn Pedersen Fox Associates

2005
11 West 53rd Street
Midtown

www.moma.org
www.kpf.com

For the extensive renovation of one of New York's most revered cultural institutions, Taniguchi has expanded the white cube, synonymous with the exhibition gallery, into a spacious stage for viewing masterpieces of modern art.

Bei der umfangreichen Renovierung einer der bedeutendsten kulturellen Einrichtungen hat Taniguchi den weißen Kubus, das Synonym für die Galerie, zu einer offenen Bühne geweitet, auf der die Meisterwerke der modernen Kunst betrachtet werden können.

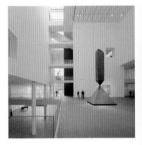

Dans le cadre de la rénovation totale de l'une des institutions culturelles les plus significatives, Taniguchi a élargi le cube blanc, synonyme de la galerie, pour en faire une scène ouverte sur laquelle on peut admirer les chef-d'œuvres de l'art moderne.

Durante la profunda restauración de uno de los edificios culturales más importantes, Taniguchi amplió el cubo blanco, sinónimo de la galería, hasta convertirlo en un escenario abierto donde se pueden contemplar las obras maestras del arte moderno.

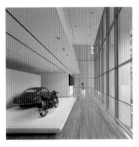

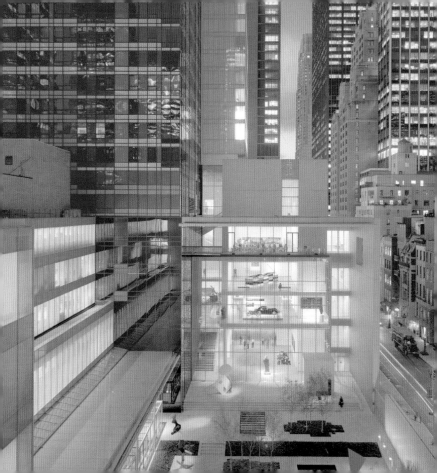

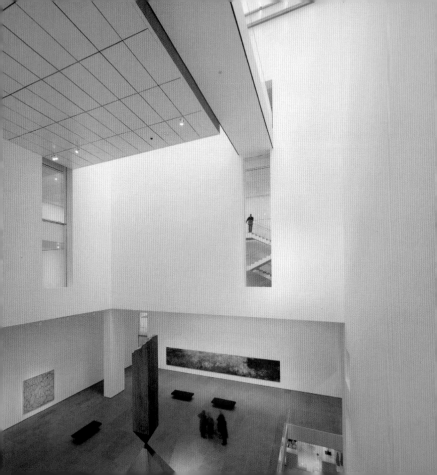

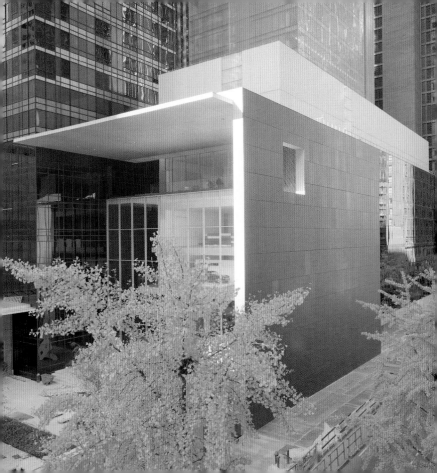

American Folk Art Museum

Tod Williams Billie Tsien Architects

2001
45 West 53rd Street
Midtown

www.folkartmuseum.org
www.twbta.com

With a deep and narrow site, a skylight opens the space with natural light that coruscates down a vertical cut extending through the museum's interior. Sumptuous and tactile finishes echo the craft-based arts exhibited at the museum.

Bei diesem, auf einem schmalen und tiefen Grundstück gebauten, Museum sorgen ein Dachfenster und ein durchgehendes vertikales Fensterband für natürliches Licht im Inneren. Die kostbaren und taktilen Oberflächen spielen auf die kunsthandwerklichen Objekte an, die im Museum ausgestellt sind.

Dans ce musée construit sur un terrain étroit et profond, une fenêtre dans le toit et une fenêtre verticale allant du sol au plafond permettent à la lumière naturelle de pénétrer à l'intérieur du bâtiment. Les surfaces précieuses et tactiles font référence aux objets artisanaux qui sont exposés dans le musée.

En este museo, levantado en un solar estrecho y profundo, la claraboya y las ventanas continuas verticales permiten el paso de la luz natural al interior. Las valiosas superficies táctiles hacen referencia a los objetos artesanales expuestos en el museo.

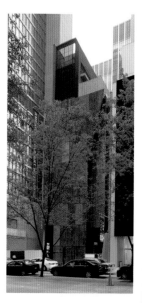

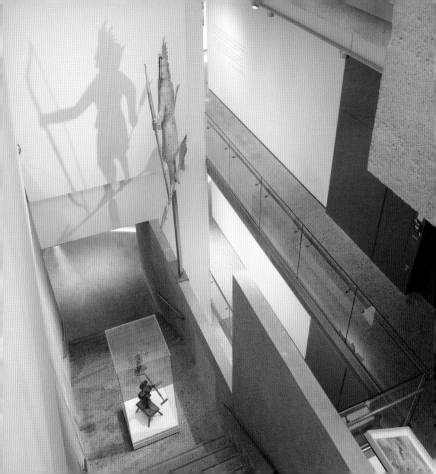

Alvin Ailey
American Dance Foundation

Iu + Bibliowicz Architects LLP

2005
405 West 55th Street
Midtown

www.alvinailey.org
www.ibarchitects.com

The building's transparent skin reveals the interior's program allocated to the largest facility devoted exclusively to dance in the United States. Dance is thereby made readily apparent on the exterior and further thrust into the urbanscape.

Die transparente Haut des Gebäudes gibt den Blick auf die Aktivitäten im Inneren frei. Dies ist die größte Einrichtung in den Vereinigten Staaten, die ausschließlich dem Tanz gewidmet ist, der nach außen sichtbar wird und in die Stadt drängt.

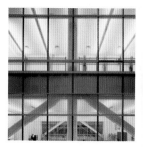

La paroi transparente du bâtiment offre une vue sur les activités à l'intérieur. C'est la plus grande institution des États-Unis exclusivement consacrée à la danse qui est visible de l'extérieur et pénètre dans la ville.

La piel transparente del edificio permite ver la actividad que se desarrolla en el interior. Esta es la mayor edificación en Estados Unidos destinado exclusivamente al baile, que es visible desde el exterior y se introduce en la ciudad.

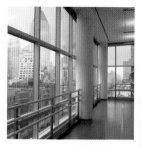

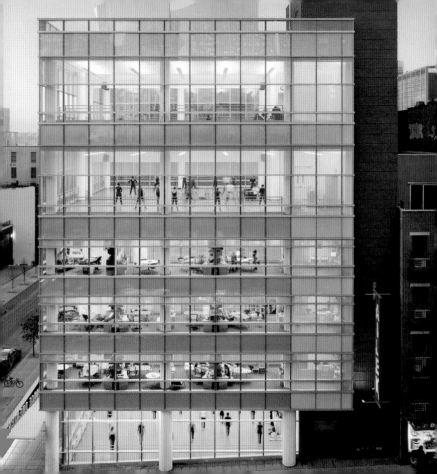

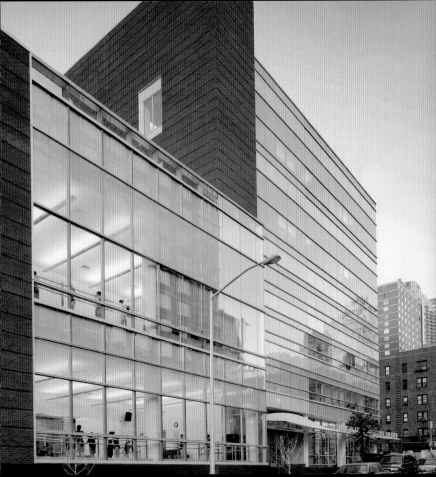

Jazz at Lincoln Center

Raphael Viñoly Architects PC

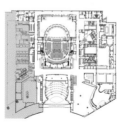

2004
Time Warner Center
33 West 60th Street/Broadway
Columbus Circle, Floors 4-6
Upper West Side

www.jazzatlincolncenter.org
www.rvapc.com

In the first performing arts center designed only for jazz music, musicians play in the Allen Room with the skyline as their backdrop. Viñoly makes his own riffs with intentionally flexible interiors that mimic the improvisational character of jazz.

Im ersten Konzerthaus, das speziell für Jazz entworfen wurde, spielen Musiker im Allen Room mit der Skyline im Hintergrund. Viñolys flexible Innenräume spiegeln den improvisierenden Charakter des Jazz wider.

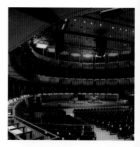

Dans cette première salle de concert conçue spécialement pour le jazz, les musiciens jouent dans l'Allen Room avec pour décor la skyline. Les pièces intérieures flexibles de Viñoly font référence à l'improvisation dans le jazz.

En la primera sala de conciertos especialmente diseñada para la interpretación de jazz, los músicos tocan en el Allen Room con el perfil de la ciudad en el fondo. Los espacios flexibles de Viñoly reflejan el carácter improvisador del jazz.

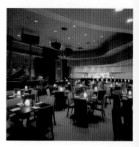

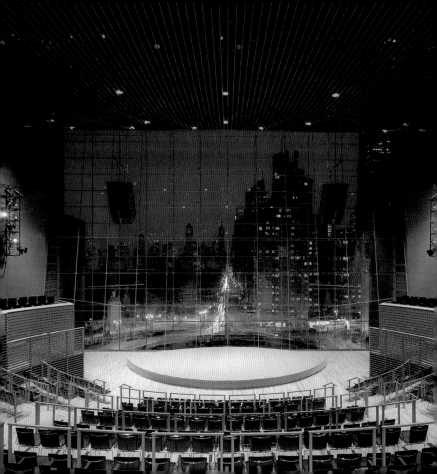

Alice Tully Hall
Lincoln Center

Diller Scofidio + Renfro
FXFOWLE Architects PC

2008
1941 Broadway
Upper West Side

www.lincolncenter.org
www.dillerscofidio.com
www.fxfowle.com

As part of Lincoln Center's larger 65th Street redevelopment, Alice Tully Hall will undergo substantial structural and cosmetic enhancements. The redesigned entrance will establish a dynamic relationship between Lincoln Center and the city.

Im Rahmen der umfassenden Sanierung von Lincoln Center und 65th Street werden an der Alice Tully Hall bedeutende strukturelle und äußerliche Veränderungen vorgenommen. Durch den Umbau des Eingangsbereichs wird eine dynamische Beziehung zwischen dem Lincoln Center und der Stadt entstehen.

Dans le cadre de la rénovation totale du Lincoln Center et de la 65th Street, Alice Tully Hall connaîtra des modifications significatives quant à sa structure et à son aspect extérieur. Le nouvel agencement de la zone d'entrée créera une relation dynamique entre le Lincoln Center et la ville.

Durante el profundo saneamiento del Lincoln Center y la 65th Street se realizarán las notables modificaciones estructurales y exteriores. Con la remodelación de la zona de la entrada se creará una relación dinámica entre el Lincoln Center y la ciudad.

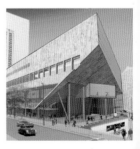

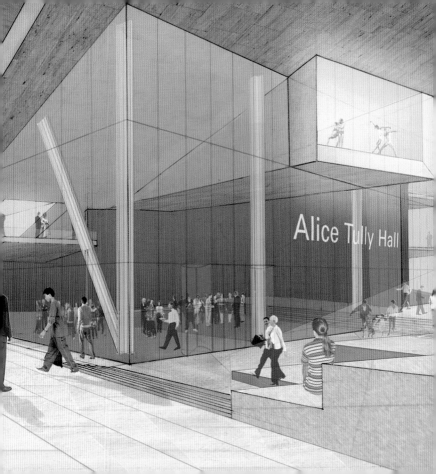

Barnard College Nexus

Weiss/Manfredi Architects

2008
Broadway between
117th and 119th Street
Morningside Heights

www.barnard.columbia.edu

Landscape furnishes the motivating design strategy behind this new multi-use arts building that is integrated into an existing college campus. A series of green terraces escalate through the building, and also bring light to the structure's core.

Die Landschaft ist Ausgangspunkt für die Designstrategie, welche dem neuen multifunktionalen Kunstzentrum zugrunde liegt, das sich in einen existierenden College-Campus integriert. Gestaffelte grüne Terrassen im Gebäudeinneren sorgen für Licht.

Le paysage est le point de départ de la stratégie adoptée en matière de design pour le nouveau centre artistique multifonctionnel qui a été intégré dans un campus universitaire existant. Les terrasses vertes décalées à l'intérieur du bâtiment garantissent de la lumière.

El paisaje es el punto de partida para la estrategia del diseño subyacente al nuevo centro artístico multifuncional que se integra en un campus ya existente. Las terrazas escalonadas en el interior del edificio proporcionan luz.

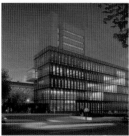

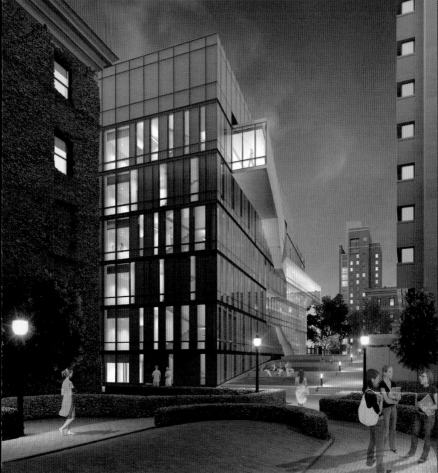

Brooklyn Museum
Entry Pavilion and Plaza

Polshek Partnership Architects LLP

2004
200 Eastern Parkway
Brooklyn

www.brooklynmuseum.org
www.polshek.com

To reintegrate the Brooklyn Museum to its site, and to enhance its relationship with its community and visitors, a new Entry Pavilion and Eastern Parkway Plaza including outdoor exhibition and performance areas were designed. The new transparent structure added to the original Beaux-Arts building further accentuates the building's accessibility.

Für eine bessere Einbindung des Brooklyn Museum und um Nachbarn wie Besucher anzusprechen, wurden ein neuer Eingangspavillon und die neue Eastern Parkway Plaza entworfen, die Raum für Ausstellungen und Performances bietet. Durch den neuen transparenten Anbau ist das ursprüngliche Beaux-Arts-Gebäude zudem besser zugänglich.

Dans le souci de mieux intégrer le Brooklyn Museum et de s'adresser aussi bien aux voisins qu'aux visiteurs, un nouveau pavillon d'entrée et la nouvelle Eastern Parkway Plaza ont été conçus et accueillent des expositions et des manifestations. Grâce à la nouvelle annexe transparente, le bâtiment des Beaux-Arts d'origine est mieux accessible.

Para conseguir una mejor integración del Brooklyn Museum y agradar tanto a vecinos como a visitantes, se proyectaron un nuevo pabellón de entrada y la nueva Eastern Parkway Plaza, que ofrece espacio para exposiciones y representaciones. Además, con el nuevo y transparente edificio anexo se accede mejor al edificio original de Beaux-Arts.

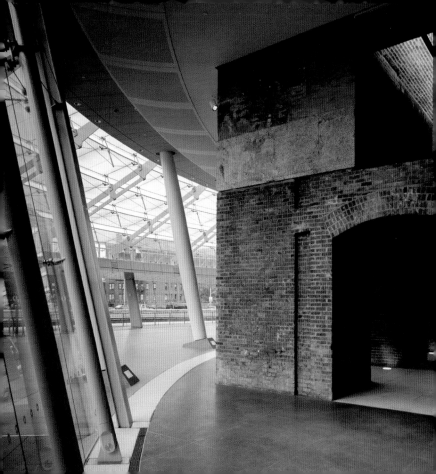

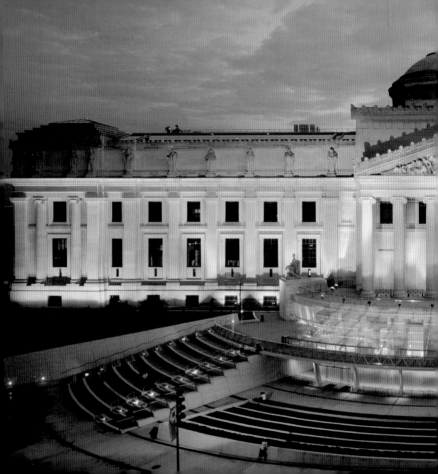

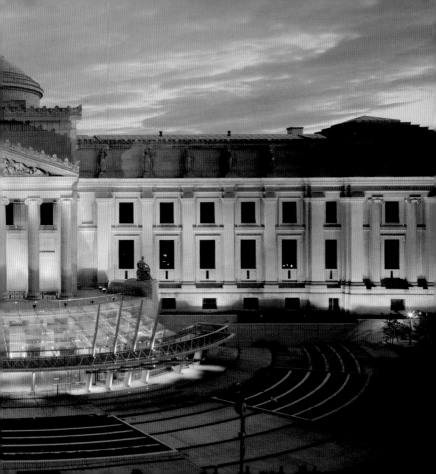

New York
Hall of Science

Polshek Partnership Architects LLP

2004
47-01 111th Street
Queens

www.nyhallsci.org
www.polshek.com

The remains of the 1964 World's Fair in Flushing Meadows-Corona Park, Queens have been transformed into an interactive science museum. The new project engages bold geometries to contrast mass positive and negative space.

Die Überreste der Weltausstellung von 1964 in Flushing Meadows' Corona Park in Queens wurden in ein interaktives Wissenschaftsmuseum verwandelt. Mit auffälligen Bauteilen wird ein Kontrast zwischen positiven und negativen Räumen erzeugt.

Les restes de l'exposition universelle de 1964 dans le Corona Park de Flushing Meadows dans le Queens ont été transformés en musée scientifique interactif. Les éléments originaux du bâtiment créent un contraste entre les pièces positives et les pièces négatives.

Los restos del Exposición Universal de 1964 en el Corona Park de Flushing Meadows en Queens fueron transformados en un museo de la Ciencia interactivo. Con componentes llamativos se establece un contraste entre los espacios positivo y negativo.

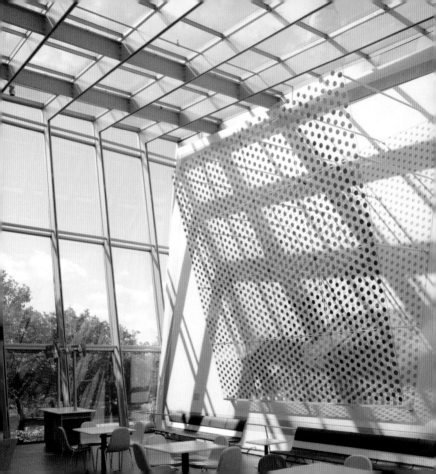

World Trade Center Transportation Hub

Santiago Calatrava

2009
Lower Manhattan

www.renewnyc.com
www.calatrava.com

Designed as a freestanding structure of glass, steel and concrete and situated on the World Trade Center site, the new transportation hub will serve passengers on commuter and subway trains and provide indoor pedestrian access to adjacent buildings. Natural light flooding in through the winglike, rectractable roof will filter down to platform level.

Der Entwurf sieht eine freistehende Konstruktion aus Glas, Stahl und Beton auf dem Gelände des World Trade Centers vor. Dieser neue, dauerhafte Verkehrsknotenpunkt für Pendlerzüge und U-Bahnen bietet zugleich einen überdachten Zugang zu den angrenzenden Gebäuden. Durch das flügelartige, verschiebbare Dach fällt natürliches Licht bis auf die Bahnsteigebene.

Le projet prévoit une construction autonome en verre et en acier et en béton sur l'emplacement du World Trade Center. Ce nouveau nœud routier permanent des trains de banlieue et de métro offre parallèlement un accès couvert aux bâtiments attenants. Le toit amovible en forme d'aile permet à la lumière naturelle d'atteindre les quais.

Diseñado como una estructura singular de vidrio, acero y hormigón y ubicado en el emplazamiento del World Trade Center, el nuevo centro de transportación ayudara a los pasajeros con las conexiones de trenes diarios y metros subterráneos, así mismo facilitara a los peatones con acceso a los edificios colindantes. A través del techo retractable en forma de ala la luz natural se filtrara hasta llegar al nivel de la plataforma.

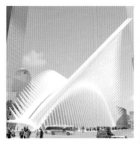

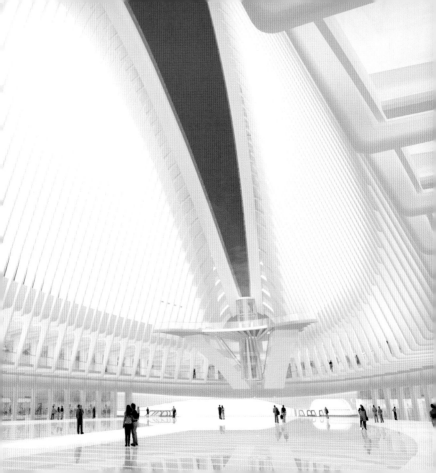

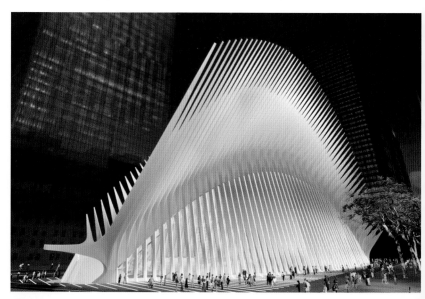

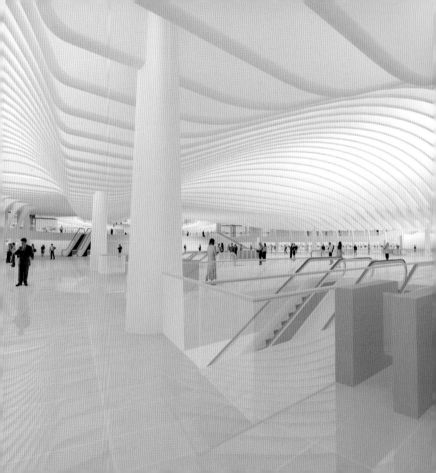

The High Line

Field Operations
Diller Scofidio + Renfro

First stage projected to open in 2008
Gansevoort St to West 20th St
Meatpacking District/Chelsea

www.thehighline.org
www.fieldoperations.net
www.dillerscofidio.com

A public promenade preserves and reuses an expansive rail structure on Manhattan's West Side. This elevated oasis provides a green space for strolling and relaxation high above the city's urban congestion.

Eine öffentliche Promenade führt eine lange Bahntrasse auf Manhattans West Side einer neuen Verwendung zu. Diese erhöhte Oase lädt zum Spazierengehen und Erholen im Grünen über dem Verkehrsgetümmel der Stadt ein.

La longue voie ferroviaire de la West Side de Manhattan a été dotée d'une nouvelle utilisation grâce à une promenade publique. Cet oasis amélioré invite à se promener et à se reposer dans la nature, au-dessus de la circulation importante de la ville.

Un paseo público proporciona a una larga vía de tren en el West Side de Manhattan un nuevo uso. Este oasis elevado invita a pasear y a descansar en la naturaleza por encima del tumulto del tráfico de la ciudad.

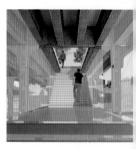

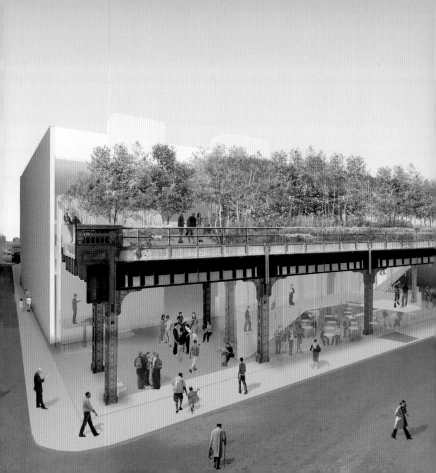

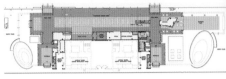

West Midtown Ferry Terminal

William Nicholas Bodouva + Associates

2005
Pier 79 between
West 38th and 40th Street
Midtown

www.bodouva.com

Located off the West Side Highway, this new 6-slip terminal on Pier 79 services passengers arriving from and departing to New Jersey. Waiting areas afford unobstructed views across the Hudson River.

Abseits des West Side Highways werden in diesem neuen Terminal mit 6 Anlegestellen am Pier 79 Passagiere abgefertigt, die aus New Jersey kommen oder dorthin reisen möchten. Die Wartebereiche bieten einen unverstellten Blick über den Hudson River.

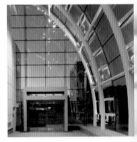

À l'écart du West Side Highway, les passagers venant de New Jersey ou souhaitant y voyager sont pris en charge dans ce nouveau terminal Pier 79 qui compte 6 embarcadères. Les salles d'attente offrent une vue authentique sur la Hudson River.

Apartada del West Side Highway, en esta nueva terminal con 6 atracaderos en el Pier 79 se factura a pasajeros provenientes de Nueva Jersey o que se dirigen allí. Las zonas de espera ofrecen una vista libre sobre el Hudson River.

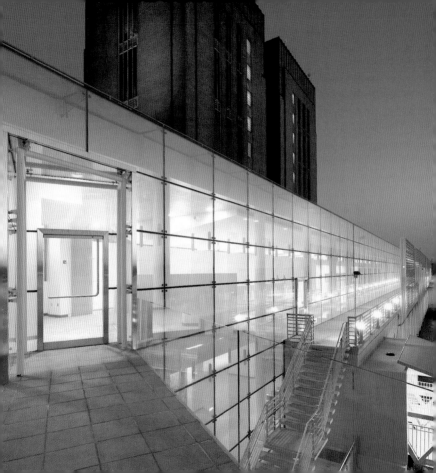

Top of the Rock
Rockefeller Center

Gabellini Sheppard Associates LLP

2005
30 Rockefeller Plaza
Midtown

www.topoftherocknyc.com
www.gabelliniassociates.com

The Observations Deck atop 30 Rockefeller Plaza that opened to the public in 1933 has been revamped and reopened. The trip to the 70th-floor summit has been enhanced by interactive displays and a profusion of crystal that makes for a luxurious journey.

Die Aussichtsplattform des 30 Rockefeller Plaza, die 1933 der Öffentlichkeit zugänglich gemacht wurde, ist modernisiert und wiedereröffnet worden. Interaktive Displays und eine Überfülle von Kristallen machen den Aufstieg zur 70. Etage zu einem luxuriösen Ausflug.

La plate-forme panoramique du 30 Rockefeller Plaza, qui a été rendue publique en 1933, a été modernisée et inaugurée de nouveau. Les écrans interactifs et des cristaux en quantité considérable font de la montée au 70ème étage une excursion de luxe.

El observatorio del 30 Rockefeller Plaza, que fue abierto al público en 1933, ha sido modernizado y reabierto. Las pantallas interactivas y la profusión de cristales convierten la subida hasta la planta 70 en una lujosa excursión.

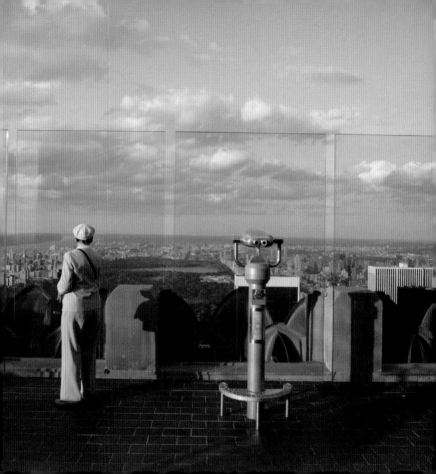

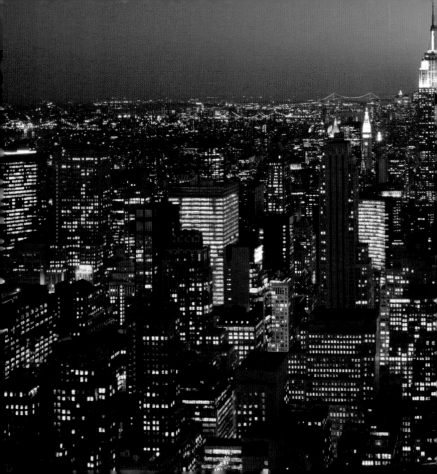

Nolen Greenhouses
for Living Collections

Mitchell/Giurgola Architects LLP

2005
The New York Botanical Garden
200th Street/Kazimiroff Boulevard
Bronx

www.nybg.org
www.mitchellgiurgola.com

These hothouses furnish horticulturists at the New York Botanical Garden with staging areas to grow a variety of plant species. Garden enthusiasts are warned that this is delicate business, so only a portion of the facility is open to the public.

Diese Treibhäuser bieten Botanikern des New Yorker Botanical Garden Räumlichkeiten, um eine Vielzahl verschiedener Pflanzen zu ziehen. Gartenfreunde seien aber gewarnt: weil es sich dabei um eine heikle Angelegenheit handelt, ist nur ein Teil der Häuser der Öffentlichkeit zugänglich.

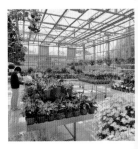

Ces serres mettent des locaux à la disposition des botanistes du Botanical Garden de New York pour qu'ils cultivent une large variété de plantes. Avertissement pour les amateurs de jardinage : étant donné qu'il s'agit d'un travail délicat, seule une partie des bâtiments est accessible au public.

Estos invernaderos ofrecen a los botánicos del Botanical Garden de Nueva York espacios para plantar diferentes especies de plantas. Los amantes del jardín deben saber, sin embargo, que se trata de un trabajo muy delicado, por lo que sólo es posible visitar parte de los invernaderos.

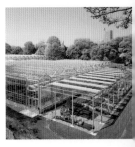

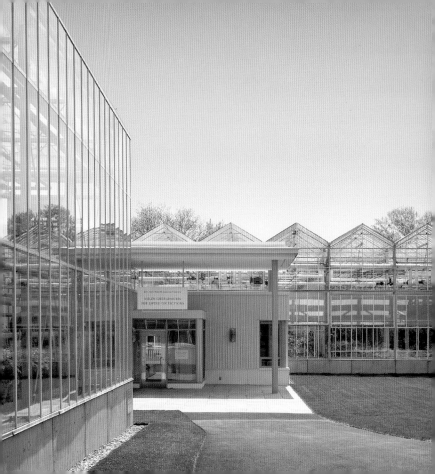

Stilwell Avenue Terminal

Kiss + Cathcart, Architects

2005
Stillwell Avenue/Surf Avenue
Coney Island

www.kisscathcart.com

The renovated train shed fuels the girth of the largest elevated station in the New York City subway system with the use of semi-transparent photovoltaic modules, thereby rejuvenating mass-transit with solar energy.

Mit der Renovierung des größten oberirdischen Bahnhofs im U-Bahnnetz von New York City hielt die Solarenergie im Öffentlichen Nahverkehr Einzug. Auf der Bahnsteigüberdachung wurden halbtransparente Photovoltaik-Module angebracht.

L'énergie solaire a fait son entrée dans les transports publics régionaux avec la rénovation de la plus grande gare aérienne du réseau métropolitain de New York City. Des modules photovoltaïques semi-transparents ont été apposés sur les abris des quais de la gare.

Con la remodelación de la mayor estación construida en superficie de la red de metro de la ciudad de Nueva York se introdujo la energía solar en el medio de transporte público. En los techos de los andenes se instalaron módulos fotovoltaicos semitransparentes.

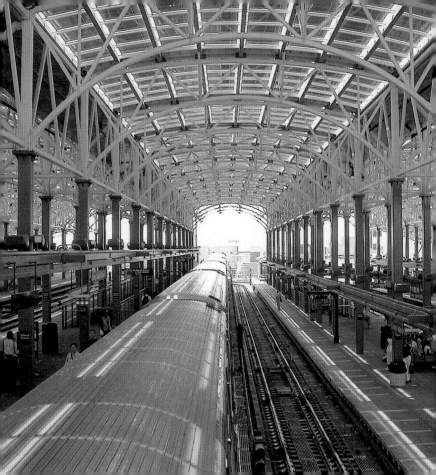

Terminal 4 JFK

Skidmore, Owings & Merrill LLP

2001
John F. Kennedy
International Airport
Queens

www.som.com

SOM has rebuilt its original 1957 terminal to accommodate the rapid growth of JFK's international arrivals. The terminal incorporates a new AirTrain system connecting to other terminals and local transportation facilities.

SOM hat sein Original-Terminal aus dem Jahr 1957 umgebaut, um dem schnellen Wachstum der internationalen Ankünfte am JFK-Flughafen gerecht zu werden. Zum Terminal gehört ein neuer AirTrain, der die Verbindung zu anderen Terminals und zum öffentlichen Nahverkehr herstellt.

SOM a réaménagé son terminal d'origine datant de 1957 afin de l'adapter à la croissance rapide des arrivées internationales à l'aéroport JFK. Le terminal dispose d'un nouveau AirTrain suspendu qui crée le lien avec les autres terminaux et avec les transports publics régionaux.

SOM remodeló su terminal original de 1957 para dar respuesta al rápido crecimiento de las llegadas de los vuelos internacionales al aeropuerto JFK. Un AirTrain forma parte de la terminal y establece la conexión con las demás terminales y con los medios de transporte públicos.

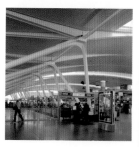

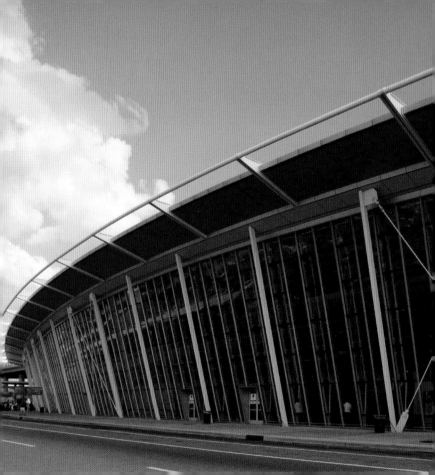

Terminal 5 JFK
JetBlue Airways

Gensler Architects

2008
John F. Kennedy
International Airport
Queens

www.jetblue.com
www.gensler.com

JetBlue's new terminal at JFK comprises Eero Saarinen's former TWA terminal. Passengers can check in at the historic structure out of which corridors radiate to a new building servicing arrivals and departures.

Das neue Terminal von JetBlue am JFK-Flughafen umfasst Eero Saarinens früheres TWA-Terminal. Die Passagiere können im alten Gebäude einchecken, aus dem Korridore zu einem neuen Bau für An- und Abflüge führen.

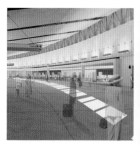

Le nouveau terminal de JetBlue à l'aéroport JFK comprend l'ancien terminal TWA d'Eero Saarinen. Les passagers peuvent embarquer dans l'ancien bâtiment dont les couloirs conduisent à un nouveau bâtiment pour les départs et les arrivées.

La nueva terminal de JetBlue en el aeropuerto JFK alberga la antigua terminal de TWA de Eero Saarinen. Los pasajeros pueden facturar en el antiguo edificio del que salen pasillos hacia el nuevo edificio para las llegadas y las salidas.

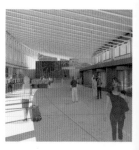

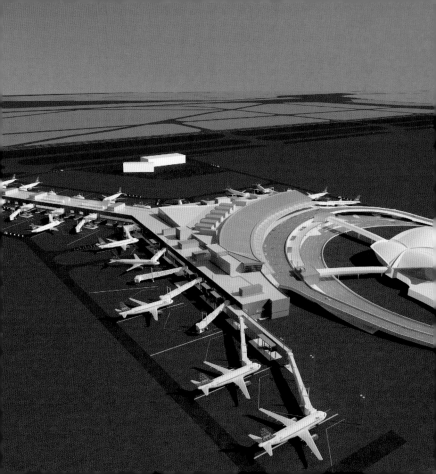

to stay . hotels

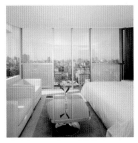

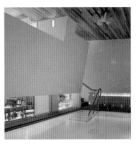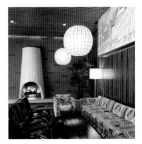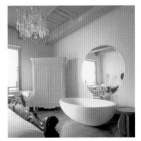

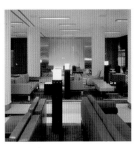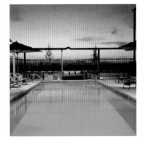

Hotel on Rivington

Grzywinski Pons Architects

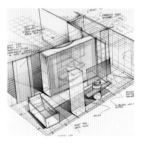

2005
107 Rivington Street
Lower East Side

www.hotelonrivington.com
www.gp-arch.com

While rocketing above the Lower East Side, rock out behind the partially frosted curtain wall of this 20-story tower. In the day natural light cascades into guest rooms, while at night they provide repose in the dark from the city below.

Durch die zum Teil aus gefrostetem Glas bestehende Vorhangfassade dieses 20-geschossigen Turms an der Lower East Side strömt tagsüber natürliches Licht in die Zimmer, während sie nachts die Lichter der Stadt dämpft.

La journée, la lumière naturelle pénètre dans la pièce par la façade rideau composée partiellement de verre givré de cette tour de 20 étages située sur la Lower East Side, alors que la nuit, elle tamise les lumières de la ville.

La fachada de muro cortina realizada con cristal escarchado de esta torre de 20 plantas en el Lower East Side, permite la entrada a borbotones de luz natural en las habitaciones durante el día mientras que, por la noche, atenúa el resplandor de las luces de la ciudad.

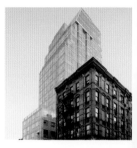

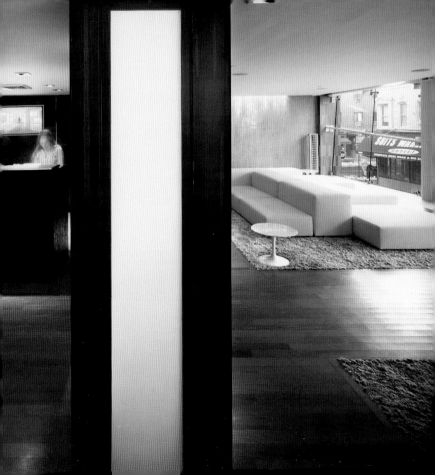

Hotel Gansevoort

Stephen B. Jacobs Group

2004
18 9th Avenue
Meatpacking District

www.hotelgansevoort.com
www.sbjgroup.com

You're sure to be insulated from any lingering effluviums while soaring above the Meatpacking District encased in the hotel's 14-floor glass and metal clad envelope. A rooftop pool doubles as a bar with 360-degree views during the warmer months.

Wer im Meatpacking District in diesem 14-stöckigen Hotel mit seiner Glas- und Stahlfassade wohnt, wird sicher nicht so schnell wieder abreisen wollen. Ein Pool auf dem Dach und eine Bar mit Panorama-Blick bieten vor allem in den warmen Monaten zusätzliche Anreize.

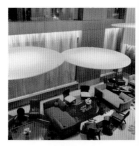

Le visiteur qui réside dans le Meatpacking District dans cet hôtel de 14 étages avec sa façade en verre et en acier ne repartira pas de si tôt. La piscine sur le toit et le bar avec vue panoramique offrent des charmes supplémentaires, principalement au cours des mois chauds.

Seguramente, quien se aloje en este hotel de 14 plantas del Meatpacking District con su fachada de vidrio y de acero no querrá marcharse tan pronto. Una piscina en el tejado y un bar con vistas panorámicas son, especialmente en los meses cálidos, un aliciente más.

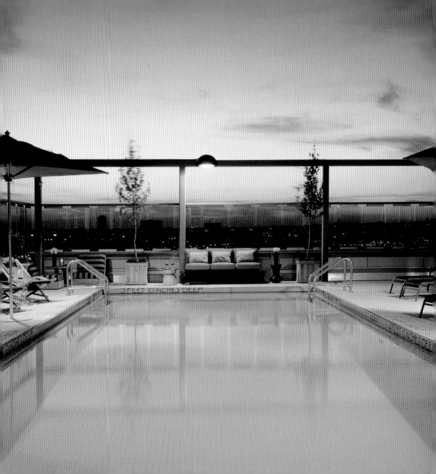

Soho House
New York

Harman & Jablin Architects LLP
Ilse Crawford (Interior Design)

2003
29-35 9th Avenue
Meatpacking District

www.sohohouseny.com
www.hjarchitects.net

Former electrical warehouse turned elite Meatpacking District club, Soho House's six floors include a hotel, restaurant and lounge, three bars, screening room, library, spa, and rooftop pool.

Das ehemalige Lagerhaus hat sich zum Elite-Club im Meatpacking District gemausert. In den sechs Etagen des Soho House gibt es ein Hotel, ein Restaurant mit Lounge, drei Bars, einen Kinosaal, eine Bibliothek, ein Spa und einen Pool auf dem Dach.

L'ancien entrepôt a acquis le statut de club d'élite dans le Meatpacking District. Sur les six étages de la Soho House, vous trouverez un hôtel, un restaurant avec lounge, trois bars, une salle de cinéma, une bibliothèque, et une piscine sur le toit.

El antiguo almacén se ha convertido en un club de élite en el Meatpacking District. En las seis plantas del Soho House hay un hotel, un restaurante con lounge, tres bares, una sala de cine, una biblioteca, un spa y una piscina en el tejado.

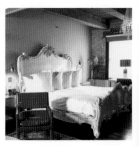

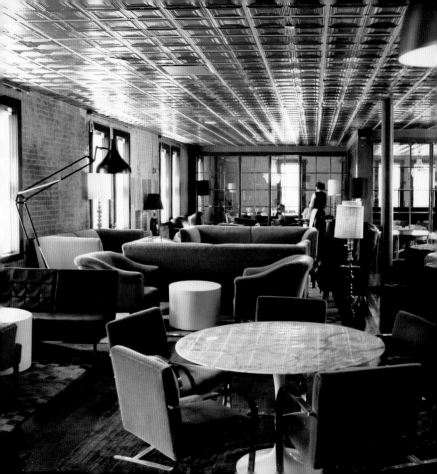

Maritime Hotel

Sean MacPherson
Eric Goode

2003
363 West 16th Street
Meatpacking District

www.themaritimehotel.com

Originally designed for the National Maritime Union in 1966, the hotel conversion retained the building's nautical evocations. With porthole shaped windows, a night at the hotel recalls a voyage on board an ocean liner without the seasickness.

Ursprünglich war das Gebäude 1966 für die National Maritime Union entworfen worden, und bei der Umwandlung zum Hotel wurden die nautischen Anspielungen beibehalten. Aufgrund der als Bullaugen geformten Fenster erinnert eine Nacht im Hotel an eine Fahrt auf einem Kreuzfahrtschiff – allerdings ohne Seekrankheit.

À l'origine, le bâtiment 1966 a été conçu pour la National Maritime Union. Les références nautiques ont été conservées lorsqu'il a été transformé en hôtel. En raison des fenêtres ayant la forme de hublots, une nuit dans l'hôtel rappelle une excursion sur un bateau de croisière, mais sans mal de mer.

Originariamente, este edificio fue diseñado en 1966 para la National Maritime Union y durante su transformación en un hotel se mantuvieron las alusiones náuticas. Las ventanas en forma de ojo de buey hacen que una noche en el hotel sea como estar de viaje en un crucero; pero sin mareos.

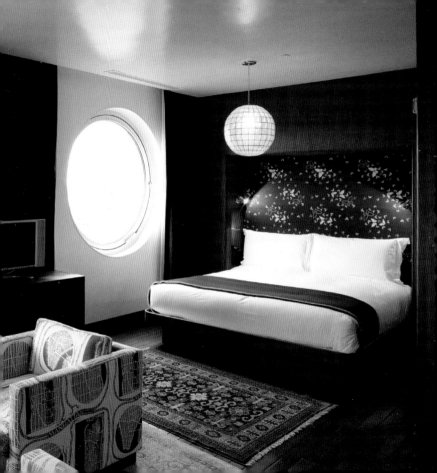

The Bryant Park Hotel

David Chipperfield
Raymond Hood & André Fouilhoux (Original Building)

2001
40 West 40th Street
Midtown

www.bryantparkhotel.com
www.davidchipperfield.com

Maverick minimalist designs mark the converted interior of the Art Deco style American Radiator Building. Guest rooms are light and airy with a neutral color palette and replete with custom designed furniture.

Extravagantes minimalistisches Design kennzeichnet die umgebauten Innenräume des im Art-Déco-Stil errichteten American Radiator Building. Die Hotelzimmer sind hell und luftig, in neutralen Farben gehalten und bieten maßgefertigtes Mobiliar.

Les pièces intérieures rénovées du American Radiator Building construites dans le style Art déco sont caractérisées par un extravagant design minimaliste. Les chambres de l'hôtel sont claires et aérées, les couleurs sont neutres et le mobilier a été réalisé sur mesure.

Un extravagante diseño minimalista caracteriza los espacios interiores remodelados del American Radiator Building, de estilo Art Deco. Las habitaciones del hotel son luminosas, están bien aireadas, se han mantenido en colores neutros y poseen un mobiliario hecho a medida.

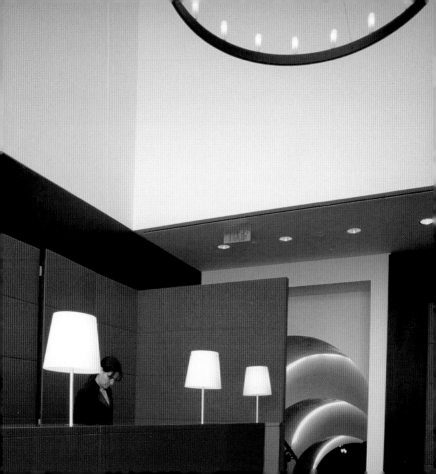

The Westin

Arquitectonica

2002
270 West 43rd Street
Times Square

www.westinny.com
www.arquitectonica.com

Arquitectonica's first skyscraper in New York, The Westin is part of the revitalization of Times Square. A volume sliced into two towers with a curved beam of light. Its five principal colors and patters on the façade are encountered on a smaller scale throughout the interior.

Das Westin ist der erste Wolkenkratzer von Arquitectonica in New York und Teil der Maßnahmen zur Neubelebung des Times Square. Der Baukörper wirkt, als sei er durch einen geschwungenen Lichtstrahl in zwei Teile geschnitten. Die fünf Hauptfarben und -muster der Fassade finden sich in kleinerem Maßstab im gesamten Gebäude wieder.

Le Westin est le premier gratte-ciel d'Arquitectonica à New York et fait partie des mesures visant à relancer l'activité du Times Square. L'édifice semble être coupé en deux par un rayon de lumière arqué. Les cinq couleurs et motifs principaux de la façade se retrouvent dans la totalité de l'édifice à une échelle plus petite.

El Westin es el primer rascacielos de Arquitectonica en Nueva York y forma parte de las medidas destinadas a revitalizar Times Square. El cuerpo de la construcción da la impresión de estar cortado en dos partes por un rayo de luz curvo. Los cinco colores y motivos principales de la fachada se vuelven a encontrar a pequeña escala en todo el edificio.

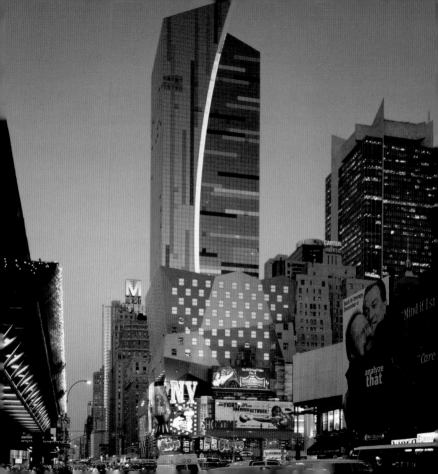

Hotel QT

ROY Co. design LLC
André Balazs Properties

2005
125 West 45th Street
Times Square

www.hotelqt.com
www.roydesign.com
www.andrebalazsproperties.com

Public and private spheres clash with an in situ pool located in the hotel's lobby. A bar and intimate lounge surround the pool that is encased in glass, so visitors who just drop in for a drink are sure to keep dry.

Öffentlicher und privater Bereich treffen am Pool aufeinander, der in der Lobby des Hotels untergebracht ist. Eine Bar sowie eine intime Lounge umgeben den Pool, der durch Glaswände abgeschirmt ist, so dass Gäste, die nur einen Drink nehmen wollen, nicht nass werden.

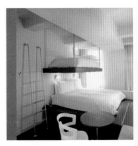

Les domaines public et privé se rejoignent au niveau de la piscine qui est intégrée dans le lobby de l'hôtel. La piscine, protégée par des parois en verre, est entourée par un bar ainsi qu'un lounge intime de façon à ce que les visiteurs qui souhaitent seulement boire un verre ne soient pas mouillés.

Los espacios público y privado se encuentran en la piscina, situada en el lobby del hotel y separada por un tabique de cristal del bar y el lounge íntimo que la rodean para que los huéspedes que sólo deseen beber algo no se mojen.

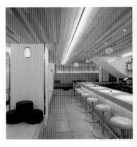

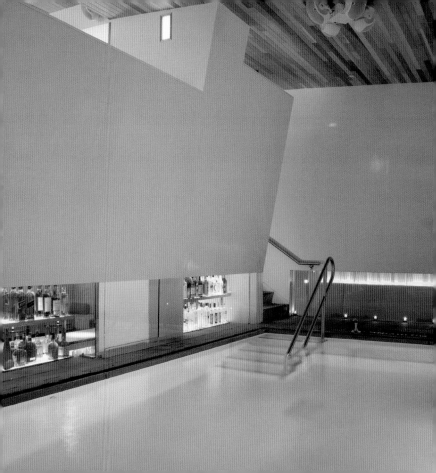

W Times Square

Yabu Pushelberg

2001
1567 Broadway
Times Square

www.starwoodhotels.com

The hotel's small lobby hardly indicates what is to come in the rest of the building. That the foyer is suspended in a glass-encased waterfall gives guests a better inclination of the luxurious experience they can expect from their stay.

Die schmale Lobby des Hotels lässt kaum ahnen, was sich im übrigen Gebäude verbirgt. Das Foyer mit seinem Wasserfall hinter Glas deutet das luxuriöse Erlebnis an, das die Gäste während ihres Aufenthaltes erwartet.

Le lobby de l'hôtel ne permet pas de devenir ce qui se cache dans le reste du bâtiment. Avec sa chute d'eau derrière une vitre, le foyer donne une indication du luxe qui est réservé aux visiteurs au cours de leur séjour.

El estrecho vestíbulo del hotel apenas permite imaginarse lo que se oculta en el resto del edificio. La entrada, con su cascada detrás de un cristal, insinúa la experiencia de lujo que les espera a los huéspedes durante su estancia.

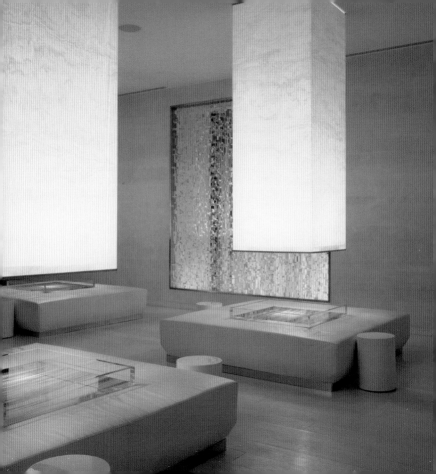

Dream Hotel

Zeffdesign

2004
210 West 55th Street
Midtown

www.dreamny.com
www.zeffdesign.com

Drift into total REM sleep in the hotel's chimerical spaces. If you have trouble relaxing, find your center at the lower-level Chopra Center. Those less spiritually inclined can opt for a cocktail on the rooftop bar.

Sollten die Räume des Hotels, die wie Trugbilder wirken, Ihnen den Schlaf rauben, bietet das Chopra-Center im unteren Stockwerk Entspannung. Wer weniger spirituell veranlagt ist, trinkt lieber einen Cocktail in der Bar auf dem Dach.

Si les pièces de l'hôtel, qui ont un effet trompe-l'oeil, vous empêchent de dormir, le centre Chopra installé à l'étage inférieur vous permettra de vous détendre. Les visiteurs peu intéressés par le spirituel préféreront boire un cocktail au bar situé sur le toit.

Si las habitaciones del hotel, que producen el efecto de un espejismo, le quitan el sueño, el Chopra Center en el piso inferior le ofrece relajación. Quien no sea propenso a lo espiritual preferirá beber un cóctel en el bar del tejado.

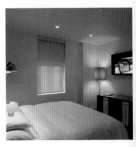

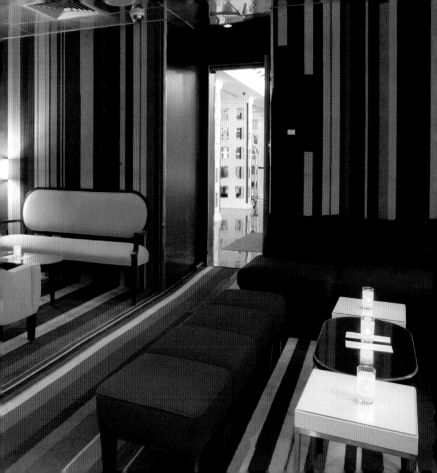

Chambers a Hotel

Rockwell Group

2001
15 West 56th Street
Midtown

www.chambershotel.com
www.rockwellgroup.com

The 14-story hotel insures an intensely intimate experience. Guests relish the hotel's public spaces that function as a living museum, boasting rotating hangs by the latest artists.

Das 14-stöckige Hotel garantiert eine intensive und intime Erfahrung. Gäste lieben die öffentlichen Räume des Hotels, die durch wechselnde Ausstellungen junger Künstler wie ein lebendiges Museum wirken.

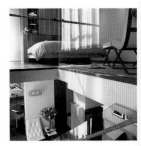

L'hôtel de 14 étages garantit une expérience intense et intime. Les visiteurs aiment les pièces publiques de l'hôtel qui font l'effet d'un musée vivant grâce aux expositions provisoires de jeunes artistes.

Este hotel de 14 plantas garantiza una experiencia intensa e íntima. Los huéspedes adoran los espacios públicos del hotel porque las cambiantes exposiciones de jóvenes artistas hacen que se asemejen a un museo viviente.

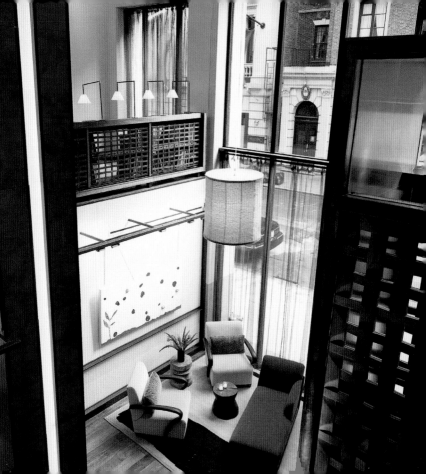

Mandarin Oriental

Brennan Beer Gorman Architects
HBA/Hirsch Bedner Associates (Interior Design)

2004
80 Columbus Circle
Upper West Side

www.mandarinoriental.com
www.bbg-bbgm.com
www.hbadesign.com

Situated inside the Times Warner Center, the Mandarin Oriental provides posh hotel accommodations on the Upper West Side. With unparalleled sophistication, guest rooms feature views of Central Park.

Das Mandarin Oriental liegt im Times Warner Center an der Upper West Side und bietet vornehme Unterkünfte. Von den Zimmern aus können die Gäste unvergleichliche Ausblicke auf den Central Park genießen.

Le Mandarin Oriental se trouve dans le Times Warner Center sur la Upper West Side et propose des hébergements de luxe. Dans les chambres, les visiteurs peuvent profiter de vues incomparables sur le Central Park.

El Mandarin Oriental está situado en el Times Warner Center, en la Upper West Side, y alberga unas elegantes estancias. Desde las habitaciones, los huéspedes pueden disfrutar de vistas iniguaables sobre el Central Park.

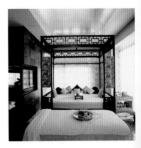

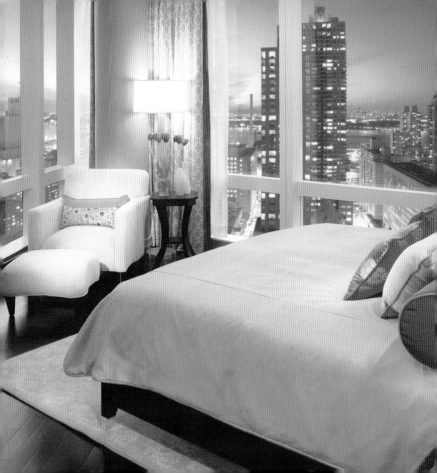

to go . eating
 drinking
 clubbing
 wellness, beauty & sport

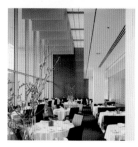

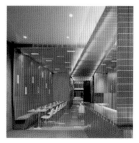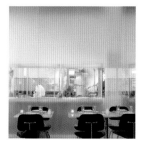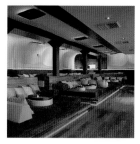

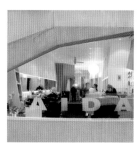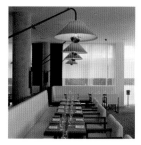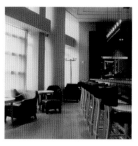

66

Richard Meier & Partners Architects

2003
241 Church Street
Tribeca

www.jean-georges.com
www.richardmeier.com

Hints of Asian inspiration permeate Meier's otherwise signature neomodernist interior at Jean-Georges Vongerichten's eatery in Tribeca. With the dining room's whitewashed walls, your plate becomes consecrated into an art object.

In Jean-Georges Vongerichtens Restaurant in Tribeca weht ein Hauch asiatischer Inspiration durch Meiers ansonsten typisch modernistische Innenräume. Vor den weißen Wänden werden die Teller der Gäste fast zu Kunstobjekten.

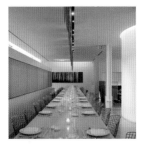

Un soupçon d'inspiration asiatique est perceptible dans le restaurant de Jean-Georges Vongerichten à Tribeca dans les pièces normalement typiquement modernistes de Meier. Placées devant les murs blancs, les assiettes des visiteurs semblent être de véritables objets d'art.

En el restaurante de Jean-Georges Vongerichten en Tribeca flota un halo de inspiración asiática por los espacios interiores de Meier, que, por otro lado, están decorados de una forma típicamente modernista. Delante de los tabiques blancos, los platos de los comensales parecen casi objetos de arte.

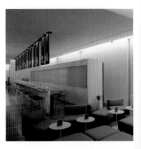

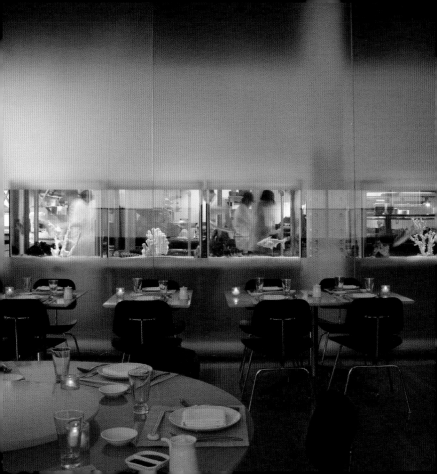

Kittichai

Rockwell Group

2003
60 Thompson Street
Soho

www.kittichairestaurant.com
www.rockwellgroup.com

With its walls draped in colorful silks and teak lattice screens, this sleek subterranean eatery located inside the 60 Thompson Hotel exudes an exotic flair that culminates in a central reflecting pool with floating candles.

Bunte Seidenvorhänge an den Wänden und Gitterraumteiler aus Teak verleihen diesem eleganten Restaurant, das im Kellergeschoss des 60 Thompson Hotels untergebracht ist, ein exotisches Flair, das im zentralen Wasserbassin mit schwimmenden Kerzen seinen Höhepunkt findet.

Les rideaux en soie colorée suspendus sur les murs et les grilles séparatrices en teck confèrent à cet élégant restaurant, qui se situe dans la cave de l'hôtel 60 Thompson, un flair exotique qui trouve son apogée dans le bassin aquatique central avec ses bougies flottantes.

Las coloridas cortinas de seda de las paredes y los separadores de espacios de rejilla de madera de teca dotan a este elegante restaurante, situado en el sótano del 60 Thompson Hotel, de un estilo exótico cuyo punto culminante es el estanque central con velas flotantes.

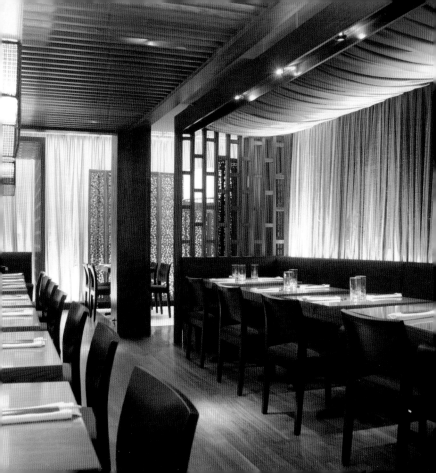

Thor

Marcel Wanders Studio

2005
107 Rivington Street
Lower East Side

www.hotelonrivington.com
www.marcelwanders.com

Located inside the Hotel on Rivington, this wallpaper-clad restaurant gives chef Kurt Gutenbrunner with a downtown venue to serves up his signature cuisine in an airy and light filled space beneath a souring 21-foot glass ceiling.

Im Hotel on Rivington in Downtown befindet sich dieses Restaurant mit gemusterten Tapeten. Die charakteristischen Kreationen des Küchenchefs Kurt Gutenbrunner werden in einem luftigen und lichtdurchfluteten Raum unter einer über sechs Meter hohen Glasdecke serviert.

Ce restaurant aux papiers peints à motifs se trouve dans l'Hotel on Rivington à Downtown. Les créations caractéristiques du chef cuisinier Kurt Gutenbrunner sont servies dans une pièce aérée et baignée de lumière sous un plafond en verre situé à six mètres de hauteur.

En el Hotel on Rivington en downtown se encuentra este restaurante con paredes empapeladas con dibujos. Las características creaciones del chef Kurt Gutenbrunner se sirven en un espacio ventilado e inundado de luz que está cubierto por un tejado de cristal situado a más de seis metros de altura.

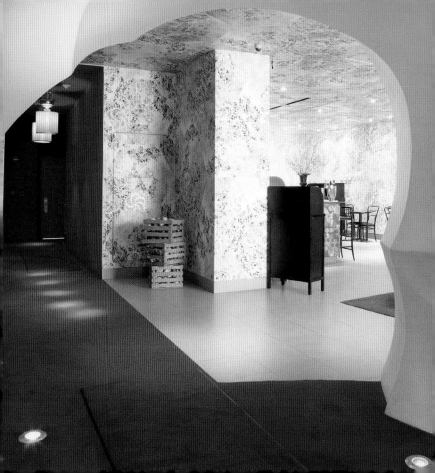

Perry St

Thomas Juul-Hansen, LLC

2005
176 Perry Street
Meatpacking District

www.jean-georges.com
www.thomasjuulhansen.com

Refined elegance abounds at this Jean-Georges Vongerichten restaurant designed by Richard Meier protégé Juul-Hansen. With completely custom designed furnishings, the décor ensures distinctive dining.

Feine Eleganz zeichnet Jean-Georges Vongerichtens Restaurant aus, das Richard Meiers Schützling Juul-Hansen entworfen hat. Mit seinen maßgefertigten Möbeln garantiert die Einrichtung ein unvergleichliches Speiseerlebnis.

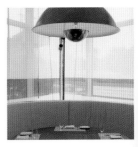

Le restaurant de Jean-Georges Vongerichten que Juul-Hansen, le protégé de Richard Meier, a conçu, se caractérise par la finesse de son élégance. Les meubles réalisés sur mesure font du repas un moment incomparable.

Este restaurante de Jean-Georges Vongerichten se caracteriza por su delicada elegancia diseñada por Juul-Hansen, pupilo de Richard Meier. Con un mobiliario hecho a medida, la decoración garantiza una inigualable experiencia culinaria.

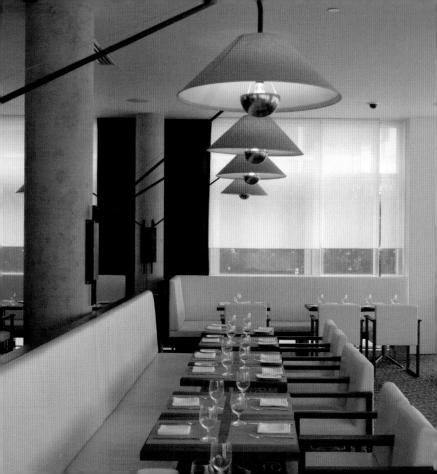

Nooch

Karim Rashid

2005
143 8th Avenue
Chelsea

www.karimrashid.com

For the design of his first New York City restaurant, Rashid puts a technocentric spin on the traditional Asian noodle shop. Menu and wait times sparkle on exterior LED displays to entertain those waiting for seats outside on the street.

Für das Design seines ersten Restaurants in New York City hat Rashid dem traditionellen asiatischen Nudel-Restaurant einen technoiden Touch verliehen. Speisekarte und Wartezeiten auf LED-Anzeigen unterhalten jene, die auf der Straße Schlange stehen.

Pour le design de son premier restaurant à New York City, Rashid a conféré une touche technoïde au traditionnel restaurant de pâtes asiatique. Les menus et les délais d'attente sont affichés sur des écrans LED et divertissent ceux qui patientent.

Para el diseño de su primer restaurante en Nueva York, Rashid dotó al tradicional restaurante de fideos asiático de un toque tecnoide. La carta y los tiempos de espera indicados en paneles de diodos entretienen a los que tienen que esperar fuera en la cola.

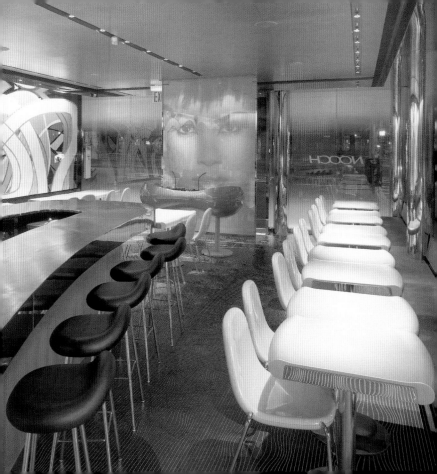

Marquee

Philip Johnson Alan Ritchie Architects

2004
289 10th Avenue
Chelsea

www.marqueeny.com
www.pjar.com

A dramatic glass-beaded chandelier illuminates the main room of this multi-level club in Chelsea. Climb to the upstairs lounge overlooking the main vaulted room to watch the swarms of people below.

In diesem Club in Chelsea, der sich über mehrere Stockwerke erstreckt, erhellt ein riesiger, mit Glasperlen besetzter Kronleuchter den überwölbten Hauptsaal, dessen Menschenschwärme sich von der oberen Lounge beobachten lassen.

Dans cette club de Chelsea qui s'étend sur plusieurs étages, un lustre géant serti de perles en verre éclaire la salle principale dotée d'une voûte : la lounge supérieure permet de regarder les personnes qui dansent en dessous.

En este club de varias plantas en Chelsea, una gigantesca araña hecha con perlas de cristal ilumina el salón principal abovedado. Desde el lounge superior es posible observar al enjambre de personas que se encuentra en el salón.

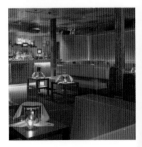

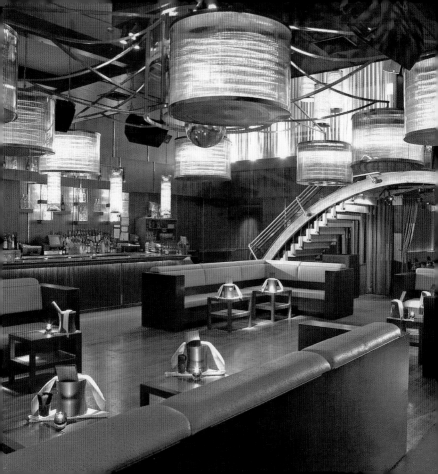

B.E.D. NYC

Oliver Hoyos

2004
530 West 27th Street
Chelsea

www.bedny.com

Eat, drink, and dance in bed once inside this relaxing restaurant and lounge that boasts beds on platforms. Those who prefer to dine upright will also find more traditional dining accommodations. Lounge on the rooftop alfresco with 360-degree views of Manhattan.

Dieses entspannende Restaurant samt Lounge bietet zahlreiche Betten auf verschiedenen Ebenen, auf denen man essen, trinken und tanzen kann. Wer lieber sitzend speist, dem werden auch traditionelle Essmöglichkeiten geboten. Die offene Lounge auf dem Dach verwöhnt mit 360°-Blicken über Manhattan.

Ce restaurant décontracté et sa lounge propose de nombreux lits sur différents niveaux pour manger, boire et danser. Les modes de repas traditionnels sont également proposés pour ceux qui préfèrent manger assis. La lounge ouverte sur le toit enchante les visiteurs avec des panoramas de 360° sur Manhattan.

Este relajante restaurante, con el lounge incluido, ofrece un gran número de camas dispuestas en diferentes plantas donde se puede comer, beber y bailar. El local ofrece también la opción tradicional para quien prefiera comer sentado. El lounge abierto situado en el tejado ofrece una vista de 360° sobre Manhattan.

136

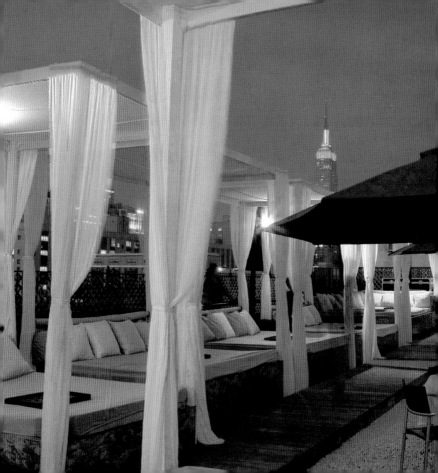

Xing Restaurant

Lewis.Tsurumaki.Lewis Architects

2004
785 9th Avenue
Midtown

www.xingrestaurant.com
www.ltlarchitects.com

This Chinese restaurant's four areas are each wrapped in a unique material including bamboo, stone, acrylic, and red velvet. A banded acrylic light canopy sweeps through the space and also provides the surface of the bar.

Die vier Bereiche dieses chinesischen Restaurants sind jeweils mit einem anderen Material ausgekleidet: Bambus, Stein, Acryl und rotem Samt. Ein Lichtband aus Acryl scheint durch den Raum zu schweben und bildet die Oberfläche der Bar.

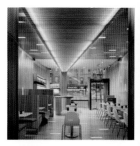

Les quatre zones de ce restaurant chinois ont chacune été revêtues d'un matériau différent : le bambou, la pierre, l'acrylique et le velours rouge. Une baie vitrée en acrylique semble flotter à travers la pièce et crée également la surface du bar.

Las cuatro áreas de este restaurante chino están revestidas con materiales diferentes: bambú, piedra, acrílico y terciopelo rojo. Una franja de luz realizada con acrílico parece flotar a través del espacio y conforma la superficie de la barra del bar.

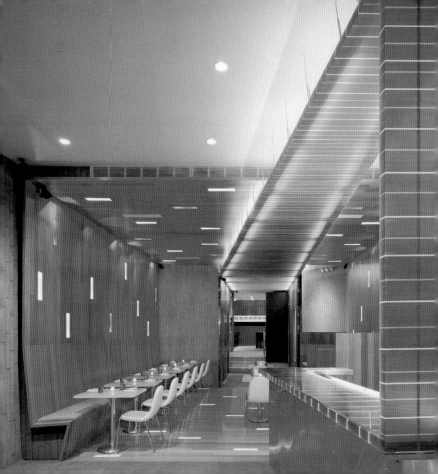

Lever House

Marc Newson

2004
390 Park Avenue
Midtown

www.leverhouse.com
www.marc-newson.com

Futuristic nostalgia brings high-end dining to mid-century corporate modernism in this restaurant located inside SOM's landmarked Lever House. Alcove banquettes behind false windows make up for the lack of natural light in this subterranean eatery.

Futuristische Nostalgie und erstklassige Küche hielten Einzug in SOMs Lever House, dem unter Denkmalschutz stehenden modernistischen Firmensitz aus der Mitte des letzten Jahrhunderts. Nischen mit Sitzbänken hinter Scheinfenstern machen das fehlende Tageslicht in diesem unterirdischen Restaurant wett.

Une nostalgie futuriste et une cuisine de première classe ont fait leur entrée dans la Lever House de SOM, le siège moderniste de l'entreprise datant du milieu du siècle dernier et classé monument historique. Les niches dans lesquelles des bancs ont été placés derrière de fausses fenêtres compensent le manque de lumière naturelle dans ce restaurant souterrain.

La nostalgia futurista y la cocina de primera entraron en la Lever House de SOM, el edificio de la sede modernista de la empresa de mediados del siglo pasado y protegido como monumento histórico. Nichos con bancos de asientos detrás de ventanas ficticias compensan la falta de luz diurna de este restaurante subterráneo.

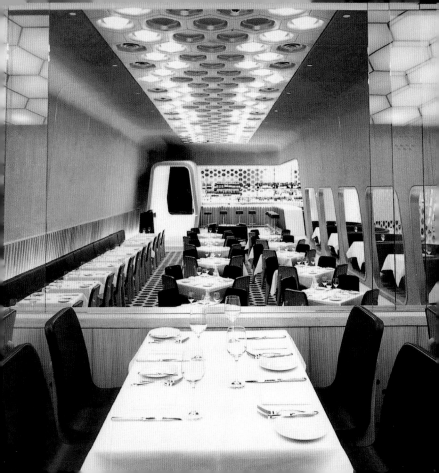

The Modern

Bentel & Bentel, Architects

2005
11 West 53 Street
Midtown

www.themodernnyc.com
www.bentelandbentel.com

This fine dining restaurant inside the premises of the Museum of Modern Art, distinguishes itself by manipulating its scale and by intensifying the presence of the materials that define it. Sinuous lighted glass walls bind the restaurant spaces to create a series of interior dining ambiances.

Dieses exklusive Restaurant im Museum of Modern Art besticht durch seine Raumverteilung und die intensive Materialpräsenz. Dezent beleuchtete Glaswände verbinden die Räume des Restaurants und lassen unterschiedliche Speiseambiente entstehen.

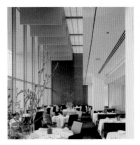

Ce restaurant exclusif dans le Museum of Modern Art séduit par la répartition de ses pièces et la présence intense de matériaux. Des parois en verre éclairement décemment relient les pièces du restaurant et créent différentes ambiances pour les repas.

Este exclusivo restaurante en el Museum of Modern Art destaca por su división espacial y su intensa presencia material. Paredes de cristal discretamente iluminadas enlazan los espacios del restaurante y crean diferentes ambientes de comedor.

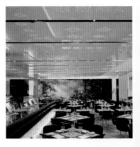

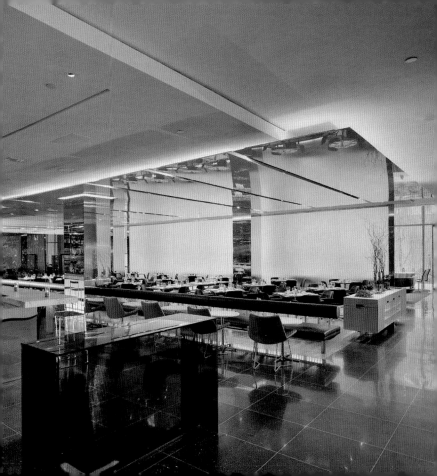

Juan Valdez Flagship Café

Hariri & Hariri - Architecture

2004
140 East 57th Street
Midtown

www.juanvaldezcafe.com
www.haririandhariri.com

The National Federation of Coffee Growers of Columbia who brought you their trademarked Juan Valdez mascot have parleyed his notoriety into a coffee shop whose streamlined storefront takes its inspiration from the shape of a coffee bean.

Die kolumbianische Vereinigung der Kaffeepflanzer hat den Ruf ihres Maskottchens Juan Valdez genutzt, um einen Coffeeshop zu eröffnen. Die geschwungene Fensterfront wurde von der Form der Kaffeebohne inspiriert.

L'Union colombienne des planteurs de café a utilisé la réputation de sa mascotte Juan Valdez pour ouvrir un coffeeshop. La façade de fenêtres arquée s'inspire de la forme du grain de café.

La Federación Nacional de Cafeteros de Colombia ha utilizado la fama de su logotipo Juan Valdez para abrir una cafetería. El frontal arqueado se inspira en la forma de un grano de café.

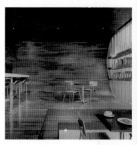

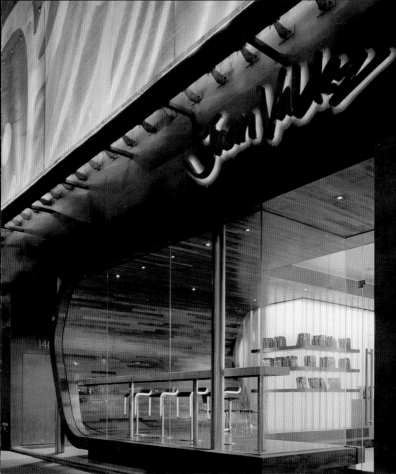

MObar

Tony Chi

2004
80 Columbus Circle
Upper West Side

www.mandarinoriental.com
www.tonychi.com

This lounge in the Time Warner Center contains limed-oak floors and leather covered seating to compliment the interior of its neighboring restaurant. With sheer linen draping the windows, the view is all about who is seated across from you.

Diese Lounge im Time Warner Center ist passend zur Einrichtung des angrenzenden Restaurants mit Fußböden aus gekalkter Eiche und Ledersesseln ausgestattet. Die Fenster sind mit reinem Leinen verhängt, so dass der Blick auf den Gegenübersitzenden nicht abgelenkt wird.

Cette lounge aménagée dans le Time Warner Center est équipée, en accord avec l'agencement du restaurant voisin, de sols en chêne recouvert à la chaux et de fauteuils en cuir. Du lin pur a été suspendu devant les fenêtres pour ne pas attirer le regard sur autre chose.

Este lounge en el Time Warner Center está equipado con suelos de roble encalado y sillones de cuero que combinan con el interior del restaurante vecino. En las ventanas cuelgan cortinas de lino puro para que la vista de los comensales no se distraiga.

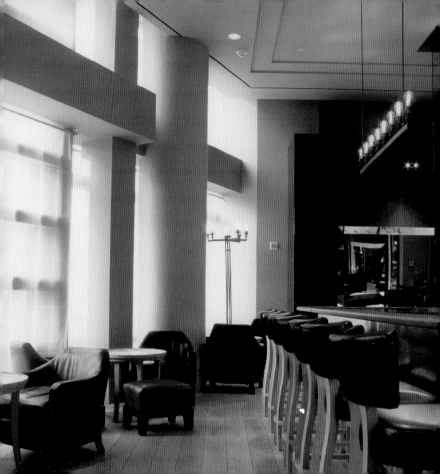

Lady M Confections

Sam Trimble Design, Inc.

2004
41 East 78th Street
Upper East Side

www.ladymconfections.com
www.samtrimble.com

A whitewashed interior accentuates the sweets at this petite cake boutique. With a custom display case among the many sumptuous details abounding, the store is as refined as the desserts sold inside.

Im weißen Innenraum kommt das süße Gebäck in dieser kleinen Konditorei besonders gut zur Geltung. Der Laden ist genauso raffiniert wie die Torten, die er anbietet.

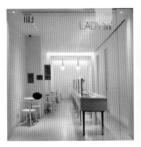

Dans cette pièce intérieure blanche, les biscuits sucrés de cette petite pâtisserie sont particulièrement bien mis en évidence. Le magasin est aussi raffiné que les gâteaux qu'il propose.

El espacio interior blanco de esta pequeña pastelería es el escenario perfecto para resaltar la dulce bollería. La tienda es igual de sofisticada que las tartas que se venden en ella.

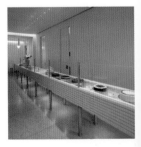

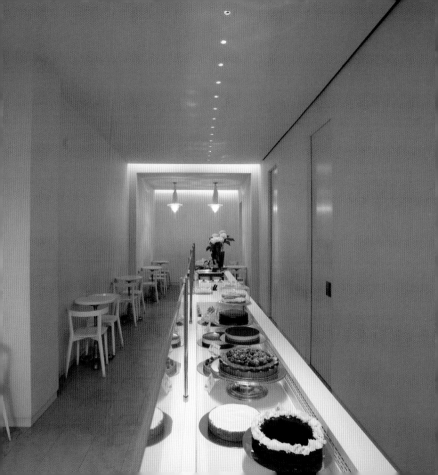

Michael Angelo's Wonderland
Beauty Parlor

EOA–Elmslie Osler Architects, P.C.
Michael Angelo + Dusti Helms (Interior Design)

2004
418 West 13th Street
Meatpacking District

www.wonderlandbeautyparlor.com
www.eoarch.com

Enter rococo redux by way of modernist reduction. Eighteenth-century salons refined the art of conversation; and while this hair salon cultivates your coiffure, it also maintains the *monde de bon goût*.

Durch modernistische Eingriffe entsteht ein reduzierter Rokoko-Stil. Salons des 18. Jahrhunderts standen für die Kunst der Konversation. Und während man sich in diesem Schönheitssalon Ihrer Haare annimmt, wird nebenbei guter Geschmack kultiviert.

Les détails modernistes créent un style rococo réduit. Les salons du 18ème siècle étaient connus pour l'art de la conversation. Pendant que l'on s'occupe de vos cheveux dans ce salon de coiffure, on cultive parallèlement le bon goût.

A través de la introducción de elementos modernistas se crea un estilo rococó reducido. Los salones del siglo XVIII se utilizaban para el arte de la conversación. En esta peluquería, además de preocuparse por su cabello, se cultiva también el buen gusto.

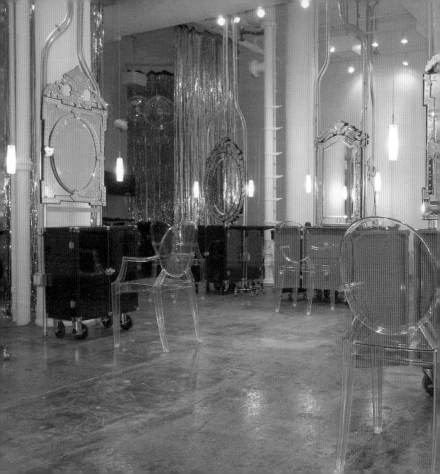

Clay

STUDIOS Architecture

2002
25 West 14th Street
Chelsea

www.insideclay.com
www.studiosarch.com

The interior of this gym is cool, sleek, and relies heavily on natural light sources. Even though it boasts a fireplace in its lobby, make no mistake that fitness is at the core of this project's design intent.

Die Ausstattung dieses Fitness-Centers ist kühl, elegant und setzt größtenteils auf natürliche Lichtquellen. Obwohl die Lobby mit einem Kamin ausgestattet ist, steht die Fitness im Mittelpunkt des Designs.

L'équipement ce centre fitness est froid, élégant et mise principalement sur les sources lumineuses naturelles. Bien que le lobby soit équipé d'une cheminée, le design met un accent principal sur le fitness.

El diseño del interior de este centro de fitness es frío, elegante y apuesta en gran parte por las fuentes de luz natural. A pesar de que el lobby está equipado con una chimenea, el deporte se encuentra en el centro del diseño.

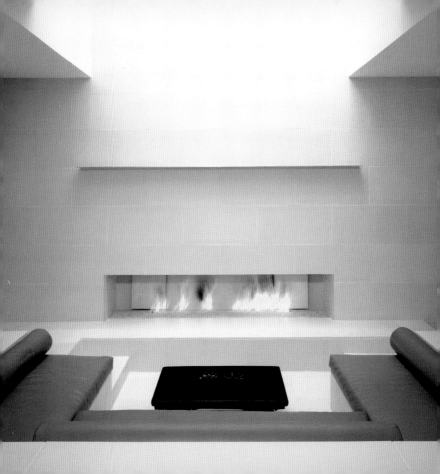

Malin & Goetz

kOnyk

2004
177 7th Avenue
Chelsea

www.konyk.net

For this flagship store featuring skin and hair care products, a Corian white box floats inside an exposed-brick shell. The design's paired down treatment compliments the brand's all natural approach to beauty products.

Bei diesem Flagshipstore für Haut- und Haarpflegemittel wurde ein aus Corian gefertigter weißer Kubus vor unverputzte Ziegelwände gesetzt. Das Design ist auf die Marke abgestimmt, die für natürliche Pflegeprodukte steht.

Pour ce magasin phare pour produits de soin de la peau et des cheveux, un cube blanc réalisé en Corian a été placé devant des parois en tuiles sans crépi. Le design s'accorde avec la marque de produits de soin naturels.

En esta tienda bandera para productos para la piel y el cabello se colocó un cubo blanco prefabricado de Corian delante de las paredes de ladrillo visto. El diseño está adaptado a la marca, que comercializa productos cosméticos naturales.

Cornelia

Mark Zeff/Zeffdesign

2005
663 5th Avenue
Midtown

www.cornelia.com
www.zeffdesign.com

This two-level day spa is the preeminent spot for the upper crust to shed last season's skin in a tranquil atmosphere with surfaces clad in neutral tones including 15 treatment rooms, a rooftop garden, and restaurant.

Dieser Tages-Spa, der sich über zwei Etagen erstreckt, ist ein Treffpunkt für die obere Schicht, die sich hier in einer ruhigen Atmosphäre runderneuern lassen kann. Neben den 15 Behandlungsräumen und dem Restaurant, die in neutralen Farben gehalten sind, gibt es auch einen Dachgarten.

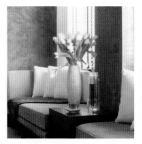

Ce spa de jour qui s'étend sur deux étages est le rendez-vous de la haute société qui vient se ressourcer ici dans une atmosphère de calme. Parallèlement aux 15 pièces de soins et au restaurant qui présentent des couleurs neutres, ce spa compte aussi un jardin sur le toit.

Este spa de día que ocupa dos plantas es un punto de encuentro para la clase alta. Aquí vienen a reponer fuerzas rodeados de una atmósfera tranquila. Además de las 15 estancias de los tratamientos y del restaurante, decorados en colores neutrales, hay también un jardín en el tejado.

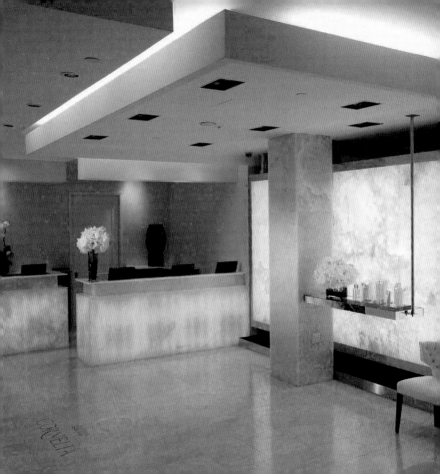

Skinclinic

Richardson Sadeki Design

2001
800 B 5th Avenue
Upper East Side

www.skinklinic.com
www.richardsonsadeki.com

Sanitized modernism marks the hygienic treatment you'll receive at this cosmetic dermatology spa. A processional ramp between the street entrance and spa offers a calming transition from the city.

Klinischer Modernismus verweist auf die hygienische Behandlung, die man in diesem Spa für kosmetische Dermatologie erfährt. Eine Rampe zwischen der Straße und dem Spa ermöglicht einen sanften Übergang aus der Stadt.

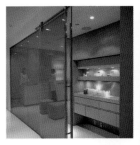

Le modernisme clinique fait référence aux soins hygiéniques dont on bénéficie dans ce spa pour dermatologie cosmétique. La rampe entre la rue et le spa permet une transition douce lorsque l'on vient de la ville.

El modernismo clínico hace referencia al tratamiento higiénico que se ofrece en este spa de dermatología cosmética. Una rampa entre la calle y el spa permite una transición suave de la ciudad al interior.

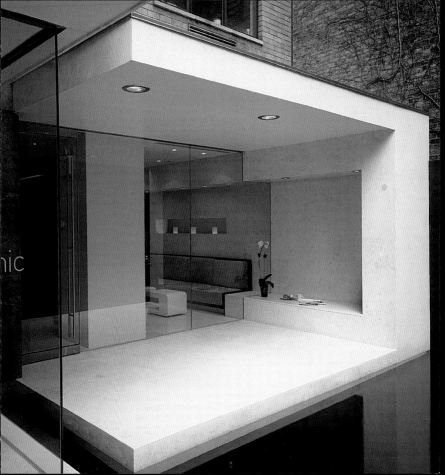

AIDA

Archi-Tectonics

2000
209 East 76th Street
Upper East Side

www.archi-tectonics.com

The sculptural stone façade folds over a single large pane of glass acting as an interface and as an urban mediator. The smooth and fluid space continues its main design concept in the interior with a pragmatic "smart wall" that folds and unfolds to become seating elements, desks and integrate lighting, sound equipment, storage and power offering an innovative experience.

Die skulpturale Steinfassade überlappt eine einzige große Glasscheibe, die als Schnittstelle und urbaner Mediator dient. Der weiche und fließende Raum setzt das wichtigste Gestaltungskonzept im Inneren mit einer gefalteten „smart wall" fort, aus der Sitzelemente und Tische wachsen und in die Beleuchtung, Lautsprecher, Schränke und Stromanschlüsse integriert sind.

La sculpturale façade en pierre chevauche une grande vitre en verre unique qui sert de jonction et de médiateur urbain. L'espace souple et fluide poursuit à l'intérieur le concept d'agencement le plus important avec un « smart wall » plié duquel s'élèvent les sièges et les tables et dans lequel l'éclairage, les haut-parleurs, les armoires et les branchements électriques sont intégrés.

La escultural fachada de piedra solapa una única y gran luna de cristal que sirve como interfaz y mediador urbano. El espacio suave y fluido hace posibles innovadoras experiencias, prolongando en el interior el concepto decorativo más importante con una "smart wall" en forma de pliegues de la que crecen asientos y mesas, y en la que están integrados la iluminación, los altavoces, los armarios y las conexiones eléctricas.

160

to shop . mall
 retail
 showrooms

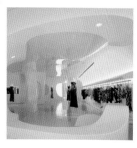 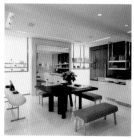

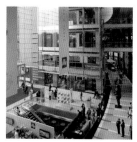 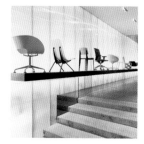

 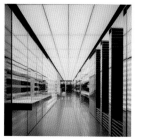

Tribeca Issey Miyake

Frank O. Gehry/Gehry Partners LLP
Gordon Kipping/G TECTS LLC.

2001
119 Hudson Street
Tribeca

www.isseymiyake.com
www.foga.com
www.gtects.com

Gehry's titanium sculpture snakes its way through the store, seemingly affecting everything in its path. Gehry protégé Gordon Kipping holds his own with his design of the store's interior for avant-garde Japanese fashion maven Miyake.

Gehrys Titan-Skulptur schlängelt sich durch den Laden und scheint alles, was auf ihrem Weg liegt, zu umfangen. Gehrys Schützling Gordon Kipping entwarf die Inneneinrichtung des Geschäfts für den avantgardistischen, japanischen Modeexperten Miyake.

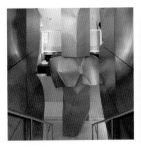

La sculpture titane de Gehry serpente dans le magasin et semble enlacer tout ce qui se trouve sur son chemin. Gordon Kipping, le protégé de Gehry, a conçu l'aménagement intérieur du magasin pour l'expert de la mode avant-gardiste japonais Miyake.

La escultura de titanio de Gehry serpentea por la tienda y parece envolver todo lo que encuentra en su camino. Gordon Kipping, pupilo de Gehry, diseñó el interior de la tienda para el vanguardista experto en moda japonés Miyake.

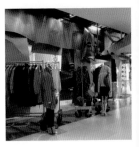

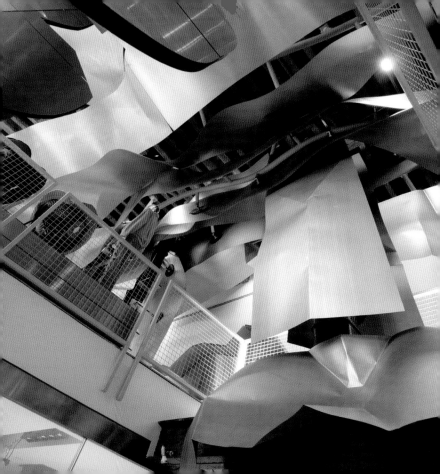

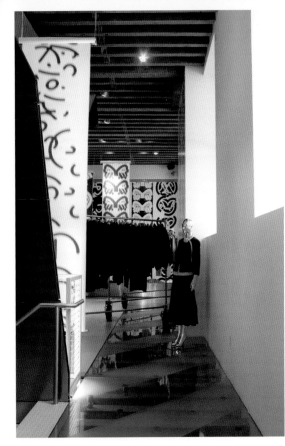

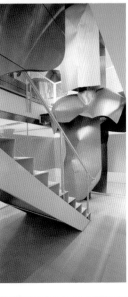

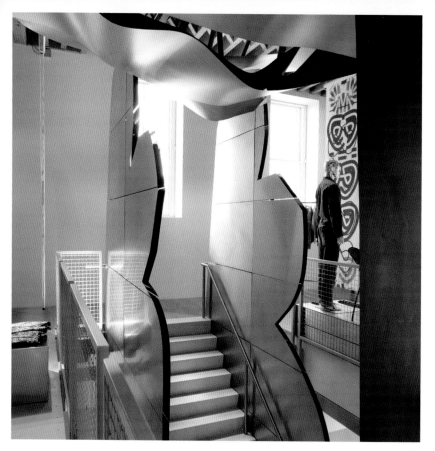

Prada

Office for Metropolitan Architecture (OMA), Rem Koolhaas, Ole Scheeren

2001
575 Broadway
Soho

www.prada.com
www.oma.nl

A sweeping semicircular ramp provides dramatic displays and doubles as a possible performance and exhibition space from which you can tunnel through corridors swelling with Muccia Prada's most forward fashions.

Eine breite, halbrunde Rampe bietet spektakuläre Präsentationen und lässt sich als Vorführungs- oder Ausstellungsfläche verwenden. Von dort aus kann der Kunde durch Gänge schlendern, in denen die neueste Mode von Muccia Prada zu finden ist.

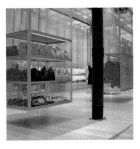

Une large rampe en demi-cercle offre des présentations spectaculaires et peut être utilisée comme surface de présentation ou d'exposition d'objets. À partir de là, le client peut flâner dans des couloirs où il découvrira la mode la plus récente de Muccia Prada.

Una amplia rampa semicircular ofrece espectaculares presentaciones y puede usarse como superficie para la presentación y la exposición. Desde ella el cliente puede deambular por los pasillos en los que encontrará lo último de Muccia Prada.

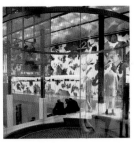

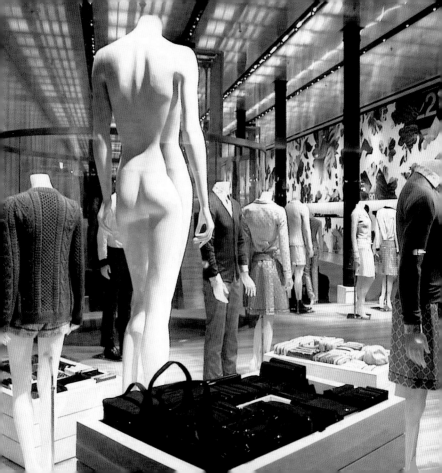

La Perla

Buratti Battiston

2003
93 Greene Street
Soho

www.laperla.com
www.burattibattiston.it

Black and white emphasizes the depth of this lofty location and a red mirror, the sensual and passionate language of La Perla. The elegant lingerie and high-class garments are exhibited on lit racks and a glass central table.

Schwarz und Weiß betonen die Tiefe des loftartigen Ladens, ein roter Spiegel die sinnliche und leidenschaftliche Sprache La Perlas. Elegante Dessous und hochwertige Bekleidung werden in beleuchteten Regalen und auf einem zentralen Glastisch präsentiert.

Le noir et le blanc soulignent la profondeur de cette boutique qui fait penser à un loft, le miroir rouge symbolise la langue sensuelle et passionnée de La Perla. Les sous-vêtements élégants et les vêtements de grande qualité sont présentés dans des étagères éclairées et sur une table en verre placée au centre de la boutique.

Negro y blanco enfatizan la profundidad de este local "lofty" y un espejo rojo la sensualidad y apasionado lenguaje de La Perla. La lencería elegante y prendas de mucha categoría se exhiben en percheros iluminados y una mesa de cristal central.

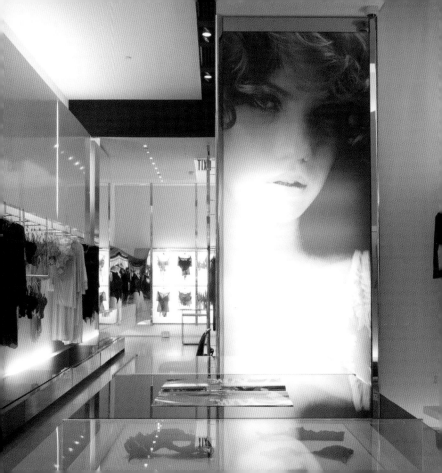

Marc Jacobs Stores
Bleecker Street

Stephan Jaklitsch Design, Inc

2004
403-405 and 385 Bleecker Street
West Village

www.marcjacobs.com
www.sjaklitsch.com

Three Marc Jacobs stores dot Bleecker Street, each with expansive glass storefronts, minimalist signage, and retractable awnings. Inside each store is light and airy with varying black and white palettes.

Drei Marc-Jacobs-Läden gibt es in der Bleecker Street. Sie alle kennzeichnen große Glasfronten, minimalistische Ladenschilder und einziehbare Markisen. Das Innere der Geschäfte ist hell, luftig und hauptsächlich in Schwarz-Weiß gehalten.

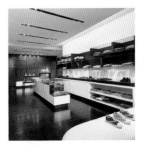

Il y a trois magasins Marc Jacobs dans la Bleecker Street. Ils sont tous dotés de grandes façades vitrées, d'enseignes minimalistes et de stores pouvant être rentré. L'intérieur des magasins est clair, aéré et décoré principalement en noir et blanc.

En la Bleecker Street hay tres tiendas de Marc Jacobs. Todas ellas se caracterizan por sus amplias cristaleras, sus rótulos minimalistas y las marquesinas retráctiles. El interior de los locales es claro, diáfano y decorado principalmente con los colores negro y blanco.

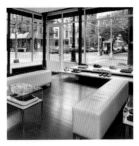

172

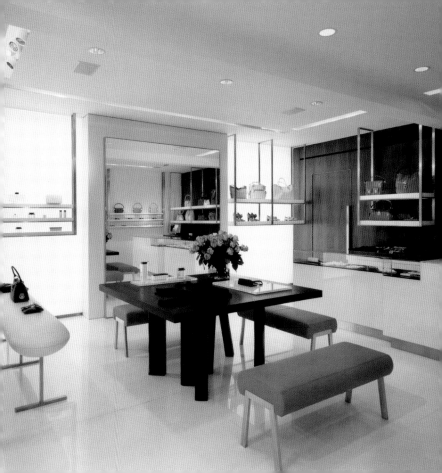

Vitra Design Store

ROY Co. design LLC

2004
29 9th Avenue
Meatpacking District

www.vitra.com
www.roydesign.com

Vitra's sleek 3-level US headquarters contains a showroom, gallery, and offices. Ramps extend through the space to display the highest pedigree of internationally acclaimed furniture designs.

Vitras elegante, dreistöckige US-Zentrale umfasst einen Ausstellungsraum, eine Galerie und Büros. Rampen durchziehen den Raum und zeigen vollendetes, international gefeiertes Möbeldesign.

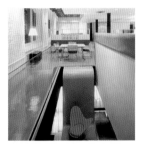

L'élégante centrale américaine de Vitra, sur trois étages, comprend une salle d'exposition, une galerie et des bureaux. Des rampes traversent la pièce et montrent un design de meuble complet et rencontrant beaucoup de succès sur le plan international.

La central estadounidense de Vitra es elegante y ocupa tres plantas que albergan una sala para las exposiciones, una galería y despachos. El espacio está atravesado por rampas y muestran un diseño de mobiliario consumado y reconocido internacionalmente.

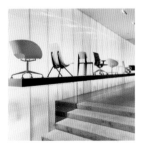

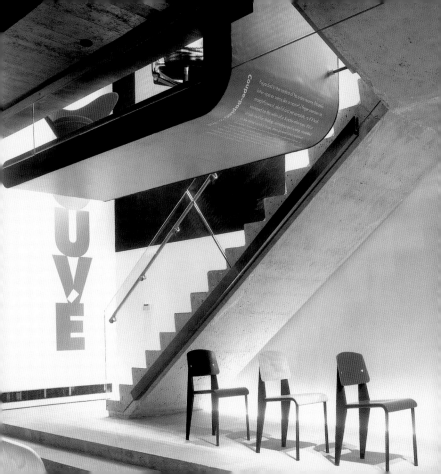

Carlos Miele Flagship Store

Asymptote, Hani Rashid, Lise Anne Couture

2003
408 West 14th Street
Meatpacking District

www.carlosmiele.com.br
www.asymptote.net

A fluid and curvaceous organism furnishes the boutique's interior frame that seemingly dissolves into whiteness to show off the *mode nouvelle* of this Brazilian fashion house.

Der Innenraum der Boutique ist fließend und kurvenreich gestaltet. Das Design scheint sich ins Weiße zu verlieren und betont damit die *mode nouvelle* dieses brasilianischen Modehauses.

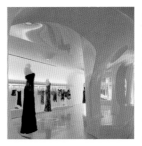

L'agencement de la pièce intérieure de la boutique est fluide et caractérisé par de nombreuses courbes. Le design semble se perdre dans le blanc et met ainsi en avant la mode nouvelle de cette maison de mode brésilienne.

El espacio interior de la boutique ha sido diseñado de una forma fluida y con muchas curvas. El diseño parece perderse en la blancura realzando así la *mode nouvelle* de esta casa de moda brasileña.

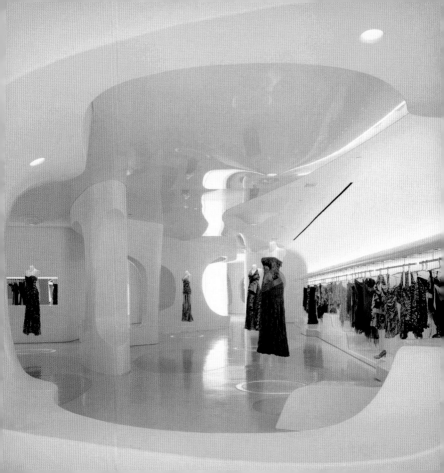

MoMA Design & Book Store

Gluckman Mayner Architects

2004
11 West 53rd Street
Midtown

www.moma.org
www.gluckmanmayner.com

Respecting Taniguchi's original concept of the MoMA building as an urban plan, the 6,000 square foot Design & Book Store, parallels the museum's block-long lobby and creates an indoor retail street. The re-creation of the material palette is characterized by the graphics of cutting-edge Dutch designer Paul Mijksenaar.

Taniguchis Grundkonzept für das MoMA-Gebäude mit seinem urbanen Grundriss folgend, verläuft der etwa 550 m² große Design & Book Store parallel zu der einen Gebäudeblock langen Lobby und schafft eine innenliegende Ladenstraße. Die gesamte Materialpalette wird bestimmt von der grafischen Gestaltung des angesagten niederländischen Designers Paul Mijksenaar.

Conformément au concept de base de Taniguchi pour le bâtiment MoMA avec un plan urbain, le Design and Book Store de près de 550 m² s'étend parallèlement au hall qui est aussi long qu'un bloc résidentiel et crée une rue commerçante intérieure. La totalité de la palette des matériaux repose sur l'agencement graphique du célèbre designer néerlandais Paul Mijksenaar.

Siguiendo el concepto básico de Taniguchi para el edificio del MoMA con una planta urbana, la Design and Book Store de unos 550 m² de superficie discurre paralela al lobby, que se extiende a lo largo de un bloque del edificio y da lugar a una calle-tienda interna. Todo el abanico de materiales está determinado por la decoración gráfica del famoso diseñador holandés Paul Mijksenaar.

Apple Store Fifth Avenue

Bohlin Cywinski Jackson

2006
767 5th Avenue, 58th Street
Midtown

www.apple.com
www.bcj.com

A 32-foot structural glass cube marks the 24 hour underground store's entrance at the plaza level. Visitors descend the glass stair or travel in the all-glass elevator, entering a carefully tailored stainless steel and stone environment where Apple's products take center stage.

Ein fast zehn Meter hoher Glaskubus auf der Plaza-Ebene markiert den Eingang des täglich 24 Stunden geöffneten unterirdischen Geschäfts. Kunden gelangen über Glasstufen oder den komplett verglasten Aufzug in eine sorgfältig abgestimmte Welt aus rostfreiem Stahl und Stein, in der die Produkte von Apple im Mittelpunkt stehen.

Un cube en verre de près de dix mètres de hauteur situé au niveau de la Plaza signalise l'entrée du magasin souterrain ouvert 24 heures sur 24. Les clients accèdent par les marches en verre ou par l'ascenseur entièrement vitré dans un monde en acier inoxydable et en pierre où règne une harmonie parfaite et dans lequel la place d'honneur revient aux produits Apple.

Un cubo de cristal estructurado de casi diez metros, señala la entrada al nivel de la plaza de la tienda subterránea abierta las 24 horas del día. Los visitantes descienden la escalera de cristal o viajan en un elevador de puro cristal para entrar a un espacio confeccionado con acero inoxidable y piedra, en donde los productos de Apple toman el centro del escenario.

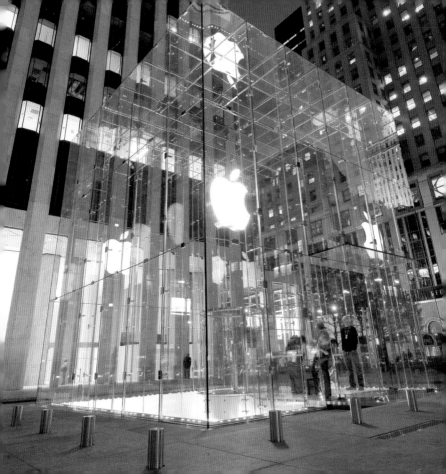

Time Warner Center

Skidmore, Owings & Merrill LLP

2004
10 Columbus Circle
Upper West Side

www.timewarner.com
www.som.com

A megastructure for Columbus Circle's crème de la crème climaxes in two glass trapezoidal towers that float above a base boasting a myriad of shopping, entertainment, and hospitality destinations.

Die Megastruktur am Columbus Circle für die Crème de la Crème gipfelt in zwei gläsernen Trapeztürmen, die sich über dem Sockelgebäude erheben. In diesem finden sich zahllose Shopping-, Unterhaltungs- und Gastronomie-Angebote.

La mégastructure du Columbus Circle pour la crème de la crème se termine avec deux tours en verre en forme de trapèze qui s'élèvent au-dessus du socle. Vous y trouverez d'innombrables offres de shopping, de divertissement et de gastronomie.

La megaestructura en el Columbus Circle para la crème de la crème acaba en dos torres trapezoidales de cristal que se levantan sobre el edificio base. Este último alberga innumerables tiendas, locales de entretenimiento y restaurantes.

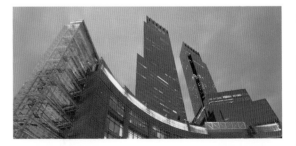

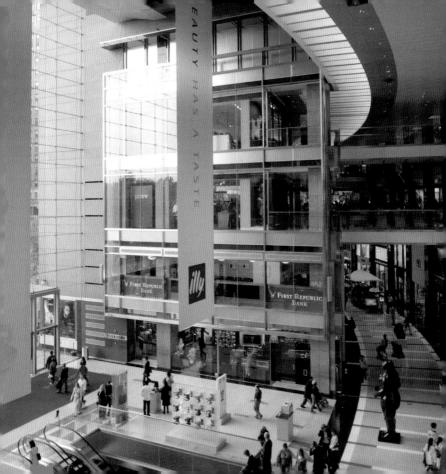

Index Architects / Designers

Index Districts

Index Districts

Photo Credits

Other photographs courtesy of

Imprint

Copyright © 2007 teNeues Verlag GmbH & Co. KG, Kempen

Second Edition

Published by teNeues Publishing Group

teNeues Verlag GmbH + Co. KG
Am Selder 37
47906 Kempen, Germany
Phone: 0049-2152-916-0
Fax: 0049-2152-916-111

teNeues Publishing Company
16 West 22nd Street
New York, N.Y. 10010, USA
Phone: 001-212-627-9090
Fax: 001-212-627-9511

teNeues France S.A.R.L.
93, rue Bannier
4500 Orléans, France
Phone: 0033-2-38 54 10 71
Fax: 0033-2-38 62 53 40

teNeues Publishing UK Ltd.
P.O. Box 402
West Byfleet, KT14 7ZF, UK
Phone: 0044-1932-403 509
Fax: 0044-1932-403 514

Press department: arehn@teneues.de
Phone: 0049-2152-916-202, www.teneues.com

ISBN: 978-3-8327-9126-1

Bibliographic information published by Die Deutsche Bibliothek
Die Deutsche Bibliothek lists this publication in the Deutsche Nationalbibliografie;
detailed bibliographic data is available in the Internet at http://dnb.ddb.de

Concept of and:guides by Martin Nicholas Kunz
Edited and written by Sean Weiss
Editorial coordination: Hanna Engelmeier,
 Katharina Feuer, Michelle Galindo
Layout: Michelle Galindo
Imaging & Pre-press, map: Jan Hausberg

Translation:
SAW Communications, Dr. Sabine A. Werner
German: Mainz Birgit Janka
French: Céline Verschelde
Spanish: Silvia Gomez de Antonio

fusion-publishing stuttgart . los angeles www.fusion-publishing.com

Printed in Italy

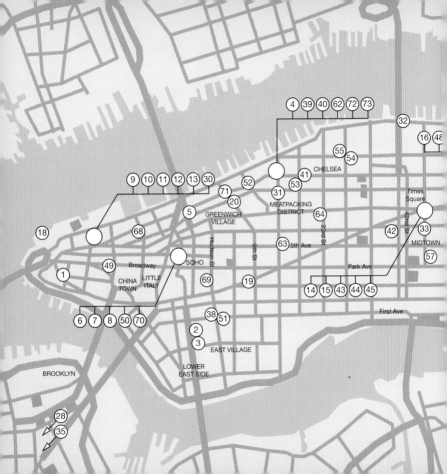